Concerning the Spiritual in Art

Wassily Kandinsky

Table of Contents

Concerning the Spiritual in Art

Wassily Kandinsky

[TRANSLATED BY MICHAEL T. H. SADLER]

TRANSLATOR'S INTRODUCTION

It is no common thing to find an artist who, even if he be willing to try, is capable of expressing his aims and ideals with any clearness and moderation. Some people will say that any such capacity is a flaw in the perfect artist, who should find his expression in line and colour, and leave the multitude to grope its way unaided towards comprehension. This attitude is a relic of the days when "l'art pour l'art" was the latest battle cry; when eccentricity of manner and irregularity of life were more important than any talent to the would–be artist; when every one except oneself was bourgeois.

The last few years have in some measure removed this absurdity, by destroying the old convention that it was middle–class to be sane, and that between the artist and the outer–world yawned a gulf which few could cross. Modern artists are beginning to realize their social duties. They are the spiritual teachers of the world, and for their teaching to have weight, it must be comprehensible. Any attempt, therefore, to bring artist and public into sympathy, to enable the latter to understand the ideals of the former, should be thoroughly welcome; and such an attempt is this book of Kandinsky's.

The author is one of the leaders of the new art movement in Munich. The group of which he is a member includes painters, poets, musicians, dramatists, critics, all working to the same end—the expression of the SOUL of nature and humanity, or, as Kandinsky terms it, the INNERER KLANG.

Perhaps the fault of this book of theory—or rather the characteristic most likely to give cause for attack—is the tendency to verbosity. Philosophy, especially in the hands of a writer of German, presents inexhaustible opportunities for vague and grandiloquent language. Partly for this reason, partly from incompetence, I have not primarily attempted to deal with the philosophical basis of Kandinsky's art. Some, probably, will find in this aspect of the book its chief interest, but better service will be done to the author's ideas by leaving them to the reader's judgement than by even the most expert criticism.

Concerning the Spiritual in Art

The power of a book to excite argument is often the best proof of its value, and my own experience has always been that those new ideas are at once most challenging and most stimulating which come direct from their author, with no intermediate discussion.

The task undertaken in this Introduction is a humbler but perhaps a more necessary one. England, throughout her history, has shown scant respect for sudden spasms of theory. Whether in politics, religion, or art, she demands an historical foundation for every belief, and when such a foundation is not forthcoming she may smile indulgently, but serious interest is immediately withdrawn. I am keenly anxious that Kandinsky's art should not suffer this fate. My personal belief in his sincerity and the future of his ideas will go for very little, but if it can be shown that he is a reasonable development of what we regard as serious art, that he is no adventurer striving for a momentary notoriety by the strangeness of his beliefs, then there is a chance that some people at least will give his art fair consideration, and that, of these people, a few will come to love it as, in my opinion, it deserves.

Post—Impressionism, that vague and much—abused term, is now almost a household word. That the name of the movement is better known than the names of its chief leaders is a sad misfortune, largely caused by the over—rapidity of its introduction into England. Within the space of two short years a mass of artists from Manet to the most recent of Cubists were thrust on a public, who had hardly realized Impressionism. The inevitable result has been complete mental chaos. The tradition of which true Post— Impressionism is the modern expression has been kept alive down the ages of European art by scattered and, until lately, neglected painters. But not since the time of the so—called Byzantines, not since the period of which Giotto and his School were the final splendid blossoming, has the "Symbolist" ideal in art held general sway over the "Naturalist." The Primitive Italians, like their predecessors the Primitive Greeks, and, in turn, their predecessors the Egyptians, sought to express the inner feeling rather than the outer reality.

This ideal tended to be lost to sight in the naturalistic revival of the Renaissance, which derived its inspiration solely from those periods of Greek and Roman art which were pre—occupied with the expression of external reality. Although the all—embracing genius of Michelangelo kept the "Symbolist" tradition alive, it is the work of El Greco that merits the complete title of "Symbolist." From El Greco springs Goya and the Spanish influence on Daumier and Manet. When it is remembered that, in the meantime, Rembrandt and his contemporaries, notably Brouwer, left their mark on French art in the

work of Delacroix, Decamps and Courbet, the way will be seen clearly open to Cezanne and Gauguin.

The phrase "symbolist tradition" is not used to express any conscious affinity between the various generations of artists. As Kandinsky says: "the relationships in art are not necessarily ones of outward form, but are founded on inner sympathy of meaning." Sometimes, perhaps frequently, a similarity of outward form will appear. But in tracing spiritual relationship only inner meaning must be taken into account.

There are, of course, many people who deny that Primitive Art had an inner meaning or, rather, that what is called "archaic expression" was dictated by anything but ignorance of representative methods and defective materials. Such people are numbered among the bitterest opponents of Post–Impressionism, and indeed it is difficult to see how they could be otherwise. "Painting," they say, "which seeks to learn from an age when art was, however sincere, incompetent and uneducated, deliberately rejects the knowledge and skill of centuries." It will be no easy matter to conquer this assumption that Primitive art is merely untrained Naturalism, but until it is conquered there seems little hope for a sympathetic understanding of the symbolist ideal.

The task is all the more difficult because of the analogy drawn by friends of the new movement between the neo–primitive vision and that of a child. That the analogy contains a grain of truth does not make it the less mischievous. Freshness of vision the child has, and freshness of vision is an important element in the new movement. But beyond this a parallel is non–existent, must be non–existent in any art other than pure artificiality. It is one thing to ape ineptitude in technique and another to acquire simplicity of vision. Simplicity—or rather discrimination of vision—is the trademark of the true Post–Impressionist. He OBSERVES and then SELECTS what is essential. The result is a logical and very sophisticated synthesis. Such a synthesis will find expression in simple and even harsh technique. But the process can only come AFTER the naturalist process and not before it. The child has a direct vision, because his mind is unencumbered by association and because his power of concentration is unimpaired by a multiplicity of interests. His method of drawing is immature; its variations from the ordinary result from lack of capacity.

Two examples will make my meaning clearer. The child draws a landscape. His picture contains one or two objects only from the number before his eyes. These are the objects

which strike him as important. So far, good. But there is no relation between them; they stand isolated on his paper, mere lumpish shapes. The Post– Impressionist, however, selects his objects with a view to expressing by their means the whole feeling of the landscape. His choice falls on elements which sum up the whole, not those which first attract immediate attention.

Again, let us take the case of the definitely religious picture.

[Footnote: Religion, in the sense of awe, is present in all true art. But here I use the term in the narrower sense to mean pictures of which the subject is connected with Christian or other worship.]

It is not often that children draw religious scenes. More often battles and pageants attract them. But since the revival of the religious picture is so noticeable a factor in the new movement, since the Byzantines painted almost entirely religious subjects, and finally, since a book of such drawings by a child of twelve has recently been published, I prefer to take them as my example. Daphne Alien's religious drawings have the graceful charm of childhood, but they are mere childish echoes of conventional prettiness. Her talent, when mature, will turn to the charming rather than to the vigorous. There could be no greater contrast between such drawing and that of—say—Cimabue. Cimabue's Madonnas are not pretty women, but huge, solemn symbols. Their heads droop stiffly; their tenderness is universal. In Gauguin's "Agony in the Garden" the figure of Christ is haggard with pain and grief. These artists have filled their pictures with a bitter experience which no child can possibly possess. I repeat, therefore, that the analogy between Post–Impressionism and child– art is a false analogy, and that for a trained man or woman to paint as a child paints is an impossibility. [Footnote: I am well aware that this statement is at variance with Kandinsky, who has contributed a long article–"Uber die Formfrage"—to Der Blaue Reiter, in which he argues the parallel between Post–Impressionism and child vision, as exemplified in the work of Henri Rousseau. Certainly Rousseau's vision is childlike. He has had no artistic training and pretends to none. But I consider that his art suffers so greatly from his lack of training, that beyond a sentimental interest it has little to recommend it.]

All this does not presume to say that the "symbolist" school of art is necessarily nobler than the "naturalist." I am making no comparison, only a distinction. When the difference in aim is fully realized, the Primitives can no longer be condemned as incompetent, nor

the moderns as lunatics, for such a condemnation is made from a wrong point of view. Judgement must be passed, not on the failure to achieve "naturalism" but on the failure to express the inner meaning.

The brief historical survey attempted above ended with the names of Cezanne and Gauguin, and for the purposes of this Introduction, for the purpose, that is to say, of tracing the genealogy of the Cubists and of Kandinsky, these two names may be taken to represent the modern expression of the "symbolist" tradition.

The difference between them is subtle but goes very deep. For both the ultimate and internal significance of what they painted counted for more than the significance which is momentary and external. Cezanne saw in a tree, a heap of apples, a human face, a group of bathing men or women, something more abiding than either photography or impressionist painting could present. He painted the "treeness" of the tree, as a modern critic has admirably expressed it. But in everything he did he showed the architectural mind of the true Frenchman. His landscape studies were based on a profound sense of the structure of rocks and hills, and being structural, his art depends essentially on reality. Though he did not scruple, and rightly, to sacrifice accuracy of form to the inner need, the material of which his art was composed was drawn from the huge stores of actual nature.

Gauguin has greater solemnity and fire than Cezanne. His pictures are tragic or passionate poems. He also sacrifices conventional form to inner expression, but his art tends ever towards the spiritual, towards that profounder emphasis which cannot be expressed in natural objects nor in words. True his abandonment of representative methods did not lead him to an abandonment of natural terms of expression—that is to say human figures, trees and animals do appear in his pictures. But that he was much nearer a complete rejection of representation than was Cezanne is shown by the course followed by their respective disciples.

The generation immediately subsequent to Cezanne, Herbin, Vlaminck, Friesz, Marquet, etc., do little more than exaggerate Cezanne's technique, until there appear the first signs of Cubism. These are seen very clearly in Herbin. Objects begin to be treated in flat planes. A round vase is represented by a series of planes set one into the other, which at a distance blend into a curve. This is the first stage.

Concerning the Spiritual in Art

The real plunge into Cubism was taken by Picasso, who, nurtured on Cezanne, carried to its perfectly logical conclusion the master's structural treatment of nature. Representation disappears. Starting from a single natural object, Picasso and the Cubists produce lines and project angles till their canvases are covered with intricate and often very beautiful series of balanced lines and curves. They persist, however, in giving them picture titles which recall the natural object from which their minds first took flight.

With Gauguin the case is different. The generation of his disciples which followed him—I put it thus to distinguish them from his actual pupils at Pont Aven, Serusier and the rest— carried the tendency further. One hesitates to mention Derain, for his beginnings, full of vitality and promise, have given place to a dreary compromise with Cubism, without visible future, and above all without humour. But there is no better example of the development of synthetic symbolism than his first book of woodcuts.

[FOOTNOTE: L'Enchanteur pourrissant, par Guillaume Apollinaire, avec illustrations gravees sur bois par Andre Derain. Paris, Kahnweiler, 1910.]

Here is work which keeps the merest semblance of conventional form, which gives its effect by startling masses of black and white, by sudden curves, but more frequently by sudden angles.

[FOOTNOTE: The renaissance of the angle in art is an interesting feature of the new movement. Not since Egyptian times has it been used with such noble effect. There is a painting of Gauguin's at Hagen, of a row of Tahitian women seated on a bench, that consists entirely of a telling design in Egyptian angles. Cubism is the result of this discovery of the angle, blended with the influence of Cezanne.]

In the process of the gradual abandonment of natural form the "angle" school is paralleled by the "curve" school, which also descends wholly from Gauguin. The best known representative is Maurice Denis. But he has become a slave to sentimentality, and has been left behind. Matisse is the most prominent French artist who has followed Gauguin with curves. In Germany a group of young men, who form the Neue Kunstlevereinigung in Munich, work almost entirely in sweeping curves, and have reduced natural objects purely to flowing, decorative units.

But while they have followed Gauguin's lead in abandoning representation both of these two groups of advance are lacking in spiritual meaning. Their aim becomes more and more decorative, with an undercurrent of suggestion of simplified form. Anyone who has studied Gauguin will be aware of the intense spiritual value of his work. The man is a preacher and a psychologist, universal by his very unorthodoxy, fundamental because he goes deeper than civilization. In his disciples this great element is wanting. Kandinsky has supplied the need. He is not only on the track of an art more purely spiritual than was conceived even by Gauguin, but he has achieved the final abandonment of all representative intention. In this way he combines in himself the spiritual and technical tendencies of one great branch of Post–Impressionism.

The question most generally asked about Kandinsky's art is: "What is he trying to do?" It is to be hoped that this book will do something towards answering the question. But it will not do everything. This—partly because it is impossible to put into words the whole of Kandinsky's ideal, partly because in his anxiety to state his case, to court criticism, the author has been tempted to formulate more than is wise. His analysis of colours and their effects on the spectator is not the real basis of his art, because, if it were, one could, with the help of a scientific manual, describe one's emotions before his pictures with perfect accuracy. And this is impossible.

Kandinsky is painting music. That is to say, he has broken down the barrier between music and painting, and has isolated the pure emotion which, for want of a better name, we call the artistic emotion. Anyone who has listened to good music with any enjoyment will admit to an unmistakable but quite indefinable thrill. He will not be able, with sincerity, to say that such a passage gave him such visual impressions, or such a harmony roused in him such emotions. The effect of music is too subtle for words. And the same with this painting of Kandinsky's. Speaking for myself, to stand in front of some of his drawings or pictures gives a keener and more spiritual pleasure than any other kind of painting. But I could not express in the least what gives the pleasure. Presumably the lines and colours have the same effect as harmony and rhythm in music have on the truly musical. That psychology comes in no one can deny. Many people—perhaps at present the very large majority of people—have their colour–music sense dormant. It has never been exercised. In the same way many people are unmusical—either wholly, by nature, or partly, for lack of experience. Even when Kandinsky's idea is universally understood there may be many who are not moved by his melody. For my part, something within me answered to Kandinsky's art the first time I met with it. There was no question of looking

for representation; a harmony had been set up, and that was enough.

Of course colour–music is no new idea. That is to say attempts have been made to play compositions in colour, by flashes and harmonies. [Footnote: Cf. "Colour Music," by A. Wallace Rimington. Hutchinson. 6s. net.] Also music has been interpreted in colour. But I do not know of any previous attempt to paint, without any reference to music, compositions which shall have on the spectator an effect wholly divorced from representative association. Kandinsky refers to attempts to paint in colour– counterpoint. But that is a different matter, in that it is the borrowing from one art by another of purely technical methods, without a previous impulse from spiritual sympathy.

One is faced then with the conflicting claims of Picasso and Kandinsky to the position of true leader of non–representative art. Picasso's admirers hail him, just as this Introduction hails Kandinsky, as a visual musician. The methods and ideas of each rival are so different that the title cannot be accorded to both. In his book, Kandinsky states his opinion of Cubism and its fatal weakness, and history goes to support his contention. The origin of Cubism in Cezanne, in a structural art that owes its very existence to matter, makes its claim to pure emotionalism seem untenable. Emotions are not composed of strata and conflicting pressures. Once abandon reality and the geometrical vision becomes abstract mathematics. It seems to me that Picasso shares a Futurist error when he endeavours to harmonize one item of reality—a number, a button, a few capital letters—with a surrounding aura of angular projections. There must be a conflict of impressions, which differ essentially in quality. One trend of modern music is towards realism of sound. Children cry, dogs bark, plates are broken. Picasso approaches the same goal from the opposite direction. It is as though he were trying to work from realism to music. The waste of time is, to my mind, equally complete in both cases. The power of music to give expression without the help of representation is its noblest possession. No painting has ever had such a precious power. Kandinsky is striving to give it that power, and prove what is at least the logical analogy between colour and sound, between line and rhythm of beat. Picasso makes little use of colour, and confines himself only to one series of line effects—those caused by conflicting angles. So his aim is smaller and more limited than Kandinsky's even if it is as reasonable. But because it has not wholly abandoned realism but uses for the painting of feeling a structural vision dependent for its value on the association of reality, because in so doing it tries to make the best of two worlds, there seems little hope for it of redemption in either.

As has been said above, Picasso and Kandinsky make an interesting parallel, in that they have developed the art respectively of Cezanne and Gauguin, in a similar direction. On the decision of Picasso's failure or success rests the distinction between Cezanne and Gauguin, the realist and the symbolist, the painter of externals and the painter of religious feeling. Unless a spiritual value is accorded to Cezanne's work, unless he is believed to be a religious painter (and religious painters need not paint Madonnas), unless in fact he is paralleled closely with Gauguin, his follower Picasso cannot claim to stand, with Kandinsky, as a prophet of an art of spiritual harmony.

If Kandinsky ever attains his ideal—for he is the first to admit that he has not yet reached his goal—if he ever succeeds in finding a common language of colour and line which shall stand alone as the language of sound and beat stands alone, without recourse to natural form or representation, he will on all hands be hailed as a great innovator, as a champion of the freedom of art. Until such time, it is the duty of those to whom his work has spoken, to bear their testimony. Otherwise he may be condemned as one who has invented a shorthand of his own, and who paints pictures which cannot be understood by those who have not the key of the cipher. In the meantime also it is important that his position should be recognized as a legitimate, almost inevitable outcome of Post–Impressionist tendencies. Such is the recognition this Introduction strives to secure.

MICHAEL T. H. SADLER

REFERENCE

Those interested in the ideas and work of Kandinsky and his fellow artists would do well to consult:

DER BLAUE REITER, vol. i. Piper Verlag, Munich, 10 mk. This sumptuous volume contains articles by Kandinsky, Franz Marc, Arnold Schonberg, etc., together with some musical texts and numerous reproductions—some in colour—of the work of the primitive mosaicists, glass–painters, and sculptors, as well as of more modern artists from Greco to Kandinsky, Marc, and their friends. The choice of illustrations gives an admirable idea of the continuity and steady growth of the new painting, sculpture, and music.

KLANGE. By Wassily Kandinsky. Piper Verlag, Munich, 30 mk. A most beautifully

produced book of prose–poems, with a large number of illustrations, many in colour. This is Kandinsky's most recent work.

Also the back and current numbers of Der Sturm, a weekly paper published in Berlin in the defence of the new art. Illustrations by Marc, Pechstein, le Fauconnier, Delaunay, Kandinsky, etc. Also poems and critical articles. Price per weekly number 25 pfg. Der Sturm has in preparation an album of reproductions of pictures and drawings by Kandinsky.

For Cubism cf. Gleizes et Metzinger, "du Cubisme," and Guillaume Apollinaire, "Les Peintres Cubistes." Collection Les Arts. Paris, Figuiere, per vol. 3 fr. 50 c.

DEDICATED TO THE MEMORY OF ELISABETH TICHEJEFF

PART 1: ABOUT GENERAL AESTHETIC

I. INTRODUCTION

Every work of art is the child of its age and, in many cases, the mother of our emotions. It follows that each period of culture produces an art of its own which can never be repeated. Efforts to revive the art–principles of the past will at best produce an art that is still–born. It is impossible for us to live and feel, as did the ancient Greeks. In the same way those who strive to follow the Greek methods in sculpture achieve only a similarity of form, the work remaining soulless for all time. Such imitation is mere aping. Externally the monkey completely resembles a human being; he will sit holding a book in front of his nose, and turn over the pages with a thoughtful aspect, but his actions have for him no real meaning.

There is, however, in art another kind of external similarity which is founded on a fundamental truth. When there is a similarity of inner tendency in the whole moral and spiritual atmosphere, a similarity of ideals, at first closely pursued but later lost to sight, a similarity in the inner feeling of any one period to that of another, the logical result will be a revival of the external forms which served to express those inner feelings in an earlier age. An example of this today is our sympathy, our spiritual relationship, with the Primitives. Like ourselves, these artists sought to express in their work only internal

truths, renouncing in consequence all consideration of external form.

This all—important spark of inner life today is at present only a spark. Our minds, which are even now only just awakening after years of materialism, are infected with the despair of unbelief, of lack of purpose and ideal. The nightmare of materialism, which has turned the life of the universe into an evil, useless game, is not yet past; it holds the awakening soul still in its grip. Only a feeble light glimmers like a tiny star in a vast gulf of darkness. This feeble light is but a presentiment, and the soul, when it sees it, trembles in doubt whether the light is not a dream, and the gulf of darkness reality. This doubt, and the still harsh tyranny of the materialistic philosophy, divide our soul sharply from that of the Primitives. Our soul rings cracked when we seek to play upon it, as does a costly vase, long buried in the earth, which is found to have a flaw when it is dug up once more. For this reason, the Primitive phase, through which we are now passing, with its temporary similarity of form, can only be of short duration.

These two possible resemblances between the art forms of today and those of the past will be at once recognized as diametrically opposed to one another. The first, being purely external, has no future. The second, being internal, contains the seed of the future within itself. After the period of materialist effort, which held the soul in check until it was shaken off as evil, the soul is emerging, purged by trials and sufferings. Shapeless emotions such as fear, joy, grief, etc., which belonged to this time of effort, will no longer greatly attract the artist. He will endeavour to awake subtler emotions, as yet unnamed. Living himself a complicated and comparatively subtle life, his work will give to those observers capable of feeling them lofty emotions beyond the reach of words.

The observer of today, however, is seldom capable of feeling such emotions. He seeks in a work of art a mere imitation of nature which can serve some definite purpose (for example a portrait in the ordinary sense) or a presentment of nature according to a certain convention ("impressionist" painting), or some inner feeling expressed in terms of natural form (as we say—a picture with Stimmung) [footnote: Stimmung is almost untranslateable. It is almost "sentiment" in the best sense, and almost "feeling." Many of Corot's twilight landscapes are full of a beautiful "Stimmung." Kandinsky uses the word later on to mean the "essential spirit" of nature.—M.T.H.S.] All those varieties of picture, when they are really art, fulfil their purpose and feed the spirit. Though this applies to the first case, it applies more strongly to the third, where the spectator does feel a corresponding thrill in himself. Such harmony or even contrast of emotion cannot be

superficial or worthless; indeed the Stimmung of a picture can deepen and purify that of the spectator. Such works of art at least preserve the soul from coarseness; they "key it up," so to speak, to a certain height, as a tuning–key the strings of a musical instrument. But purification, and extension in duration and size of this sympathy of soul, remain one–sided, and the possibilities of the influence of art are not exerted to their utmost.

Imagine a building divided into many rooms. The building may be large or small. Every wall of every room is covered with pictures of various sizes; perhaps they number many thousands. They represent in colour bits of nature—animals in sunlight or shadow, drinking, standing in water, lying on the grass; near to, a Crucifixion by a painter who does not believe in Christ; flowers; human figures sitting, standing, walking; often they are naked; many naked women, seen foreshortened from behind; apples and silver dishes; portrait of Councillor So and So; sunset; lady in red; flying duck; portrait of Lady X; flying geese; lady in white; calves in shadow flecked with brilliant yellow sunlight; portrait of Prince Y; lady in green. All this is carefully printed in a book—name of artist—name of picture. People with these books in their hands go from wall to wall, turning over pages, reading the names. Then they go away, neither richer nor poorer than when they came, and are absorbed at once in their business, which has nothing to do with art. Why did they come? In each picture is a whole lifetime imprisoned, a whole lifetime of fears, doubts, hopes, and joys.

Whither is this lifetime tending? What is the message of the competent artist? "To send light into the darkness of men's hearts—such is the duty of the artist," said Schumann. "An artist is a man who can draw and paint everything," said Tolstoi.

Of these two definitions of the artist's activity we must choose the second, if we think of the exhibition just described. On one canvas is a huddle of objects painted with varying degrees of skill, virtuosity and vigour, harshly or smoothly. To harmonize the whole is the task of art. With cold eyes and indifferent mind the spectators regard the work. Connoisseurs admire the "skill" (as one admires a tightrope walker), enjoy the "quality of painting" (as one enjoys a pasty). But hungry souls go hungry away.

The vulgar herd stroll through the rooms and pronounce the pictures "nice" or "splendid." Those who could speak have said nothing, those who could hear have heard nothing. This condition of art is called "art for art's sake." This neglect of inner meanings, which is the life of colours, this vain squandering of artistic power is called "art for art's sake."

...ist seeks for material reward for his dexterity, his power of vision and experience. His purpose becomes the satisfaction of vanity and greed. In place of the steady co–operation of artists is a scramble for good things. There are complaints of excessive competition, of over–production. Hatred, partisanship, cliques, jealousy, intrigues are the natural consequences of this aimless, materialist art.

[Footnote: The few solitary exceptions do not destroy the truth of this sad and ominous picture, and even these exceptions are chiefly believers in the doctrine of art for art's sake. They serve, therefore, a higher ideal, but one which is ultimately a useless waste of their strength. External beauty is one element of a spiritual atmosphere. But beyond this positive fact (that what is beautiful is good) it has the weakness of a talent not used to the full. (The word talent is employed in the biblical sense.)]

The onlooker turns away from the artist who has higher ideals and who cannot see his life purpose in an art without aims.

Sympathy is the education of the spectator from the point of view of the artist. It has been said above that art is the child of its age. Such an art can only create an artistic feeling which is already clearly felt. This art, which has no power for the future, which is only a child of the age and cannot become a mother of the future, is a barren art. She is transitory and to all intent dies the moment the atmosphere alters which nourished her.

The other art, that which is capable of educating further, springs equally from contemporary feeling, but is at the same time not only echo and mirror of it, but also has a deep and powerful prophetic strength.

The spiritual life, to which art belongs and of which she is one of the mightiest elements, is a complicated but definite and easily definable movement forwards and upwards. This movement is the movement of experience. It may take different forms, but it holds at bottom to the same inner thought and purpose.

Veiled in obscurity are the causes of this need to move ever upwards and forwards, by sweat of the brow, through sufferings and fears. When one stage has been accomplished, and many evil stones cleared from the road, some unseen and wicked hand scatters new obstacles in the way, so that the path often seems blocked and totally obliterated. But there never fails to come to the rescue some human being, like ourselves in everything

except that he has in him a secret power of vision.

He sees and points the way. The power to do this he would sometimes fain lay aside, for it is a bitter cross to bear. But he cannot do so. Scorned and hated, he drags after him over the stones the heavy chariot of a divided humanity, ever forwards and upwards.

Often, many years after his body has vanished from the earth, men try by every means to recreate this body in marble, iron, bronze, or stone, on an enormous scale. As if there were any intrinsic value in the bodily existence of such divine martyrs and servants of humanity, who despised the flesh and lived only for the spirit! But at least such setting up of marble is a proof that a great number of men have reached the point where once the being they would now honour, stood alone.

II. THE MOVEMENT OF THE TRIANGLE

The life of the spirit may be fairly represented in diagram as a large acute-angled triangle divided horizontally into unequal parts with the narrowest segment uppermost. The lower the segment the greater it is in breadth, depth, and area.

The whole triangle is moving slowly, almost invisibly forwards and upwards. Where the apex was today the second segment is tomorrow; what today can be understood only by the apex and to the rest of the triangle is an incomprehensible gibberish, forms tomorrow the true thought and feeling of the second segment.

At the apex of the top segment stands often one man, and only one. His joyful vision cloaks a vast sorrow. Even those who are nearest to him in sympathy do not understand him. Angrily they abuse him as charlatan or madman. So in his lifetime stood Beethoven, solitary and insulted.

[footnote: Weber, composer of Der Freischutz, said of Beethoven's Seventh Symphony: "The extravagances of genius have reached the limit; Beethoven is now ripe for an asylum." Of the opening phrase, on a reiterated "e," the Abbe Stadler said to his neighbour, when first he heard it: "Always that miserable 'e'; he seems to be deaf to it himself, the idiot!"]

Concerning the Spiritual in Art

How many years will it be before a greater segment of the triangle reaches the spot where he once stood alone? Despite memorials and statues, are they really many who have risen to his level? [Footnote 2: Are not many monuments in themselves answers to that question?]

In every segment of the triangle are artists. Each one of them who can see beyond the limits of his segment is a prophet to those about him, and helps the advance of the obstinate whole. But those who are blind, or those who retard the movement of the triangle for baser reasons, are fully understood by their fellows and acclaimed for their genius. The greater the segment (which is the same as saying the lower it lies in the triangle) so the greater the number who understand the words of the artist. Every segment hungers consciously or, much more often, unconsciously for their corresponding spiritual food. This food is offered by the artists, and for this food the segment immediately below will tomorrow be stretching out eager hands.

This simile of the triangle cannot be said to express every aspect of the spiritual life. For instance, there is never an absolute shadow–side to the picture, never a piece of unrelieved gloom. Even too often it happens that one level of spiritual food suffices for the nourishment of those who are already in a higher segment. But for them this food is poison; in small quantities it depresses their souls gradually into a lower segment; in large quantities it hurls them suddenly into the depths ever lower and lower. Sienkiewicz, in one of his novels, compares the spiritual life to swimming; for the man who does not strive tirelessly, who does not fight continually against sinking, will mentally and morally go under. In this strait a man's talent (again in the biblical sense) becomes a curse—and not only the talent of the artist, but also of those who eat this poisoned food. The artist uses his strength to flatter his lower needs; in an ostensibly artistic form he presents what is impure, draws the weaker elements to him, mixes them with evil, betrays men and helps them to betray themselves, while they convince themselves and others that they are spiritually thirsty, and that from this pure spring they may quench their thirst. Such art does not help the forward movement, but hinders it, dragging back those who are striving to press onward, and spreading pestilence abroad.

Such periods, during which art has no noble champion, during which the true spiritual food is wanting, are periods of retrogression in the spiritual world. Ceaselessly souls fall from the higher to the lower segments of the triangle, and the whole seems motionless, or even to move down and backwards. Men attribute to these blind and dumb periods a

16

special value, for they judge them by outward results, thinking only of material well–being. They hail some technical advance, which can help nothing but the body, as a great achievement. Real spiritual gains are at best under–valued, at worst entirely ignored.

The solitary visionaries are despised or regarded as abnormal and eccentric. Those who are not wrapped in lethargy and who feel vague longings for spiritual life and knowledge and progress, cry in harsh chorus, without any to comfort them. The night of the spirit falls more and more darkly. Deeper becomes the misery of these blind and terrified guides, and their followers, tormented and unnerved by fear and doubt, prefer to this gradual darkening the final sudden leap into the blackness.

At such a time art ministers to lower needs, and is used for material ends. She seeks her substance in hard realities because she knows of nothing nobler. Objects, the reproduction of which is considered her sole aim, remain monotonously the same. The question "what?" disappears from art; only the question "how?" remains. By what method are these material objects to be reproduced? The word becomes a creed. Art has lost her soul.

In the search for method the artist goes still further. Art becomes so specialized as to be comprehensible only to artists, and they complain bitterly of public indifference to their work. For since the artist in such times has no need to say much, but only to be notorious for some small originality and consequently lauded by a small group of patrons and connoisseurs (which incidentally is also a very profitable business for him), there arise a crowd of gifted and skilful painters, so easy does the conquest of art appear. In each artistic circle are thousands of such artists, of whom the majority seek only for some new technical manner, and who produce millions of works of art without enthusiasm, with cold hearts and souls asleep.

Competition arises. The wild battle for success becomes more and more material. Small groups who have fought their way to the top of the chaotic world of art and picture–making entrench themselves in the territory they have won. The public, left far behind, looks on bewildered, loses interest and turns away.

But despite all this confusion, this chaos, this wild hunt for notoriety, the spiritual triangle, slowly but surely, with irresistible strength, moves onwards and upwards.

The invisible Moses descends from the mountain and sees the dance round the golden calf. But he brings with him fresh stores of wisdom to man.

First by the artist is heard his voice, the voice that is inaudible to the crowd. Almost unknowingly the artist follows the call. Already in that very question "how?" lies a hidden seed of renaissance. For when this "how?" remains without any fruitful answer, there is always a possibility that the same "something" (which we call personality today) may be able to see in the objects about it not only what is purely material but also something less solid; something less "bodily" than was seen in the period of realism, when the universal aim was to reproduce anything "as it really is" and without fantastic imagination.

[Footnote: Frequent use is made here of the terms "material" and "non−material," and of the intermediate phrases "more" or "less material." Is everything material? or is EVERYTHING spiritual? Can the distinctions we make between matter and spirit be nothing but relative modifications of one or the other? Thought which, although a product of the spirit, can be defined with positive science, is matter, but of fine and not coarse substance. Is whatever cannot be touched with the hand, spiritual? The discussion lies beyond the scope of this little book; all that matters here is that the boundaries drawn should not be too definite.]

If the emotional power of the artist can overwhelm the "how?" and can give free scope to his finer feelings, then art is on the crest of the road by which she will not fail later on to find the "what" she has lost, the "what" which will show the way to the spiritual food of the newly awakened spiritual life. This "what?" will no longer be the material, objective "what" of the former period, but the internal truth of art, the soul without which the body (i.e. the "how") can never be healthy, whether in an individual or in a whole people.

THIS "WHAT" IS THE INTERNAL TRUTH WHICH ONLY ART CAN DIVINE, WHICH ONLY ART CAN EXPRESS BY THOSE MEANS OF EXPRESSION WHICH ARE HERS ALONE.

III. SPIRITUAL REVOLUTION

The spiritual triangle moves slowly onwards and upwards. Today one of the largest of the

lower segments has reached the point of using the first battle cry of the materialist creed. The dwellers in this segment group themselves round various banners in religion. They call themselves Jews, Catholics, Protestants, etc. But they are really atheists, and this a few either of the boldest or the narrowest openly avow. "Heaven is empty," "God is dead." In politics these people are democrats and republicans. The fear, horror and hatred which yesterday they felt for these political creeds they now direct against anarchism, of which they know nothing but its much dreaded name.

In economics these people are Socialists. They make sharp the sword of justice with which to slay the hydra of capitalism and to hew off the head of evil.

Because the inhabitants of this great segment of the triangle have never solved any problem independently, but are dragged as it were in a cart by those the noblest of their fellowmen who have sacrificed themselves, they know nothing of the vital impulse of life which they regard always vaguely from a great distance. They rate this impulse lightly, putting their trust in purposeless theory and in the working of some logical method.

The men of the segment next below are dragged slowly higher, blindly, by those just described. But they cling to their old position, full of dread of the unknown and of betrayal. The higher segments are not only blind atheists but can justify their godlessness with strange words; for example, those of Virchow—so unworthy of a learned man—"I have dissected many corpses, but never yet discovered a soul in any of them."

In politics they are generally republican, with a knowledge of different parliamentary procedures; they read the political leading articles in the newspapers. In economics they are socialists of various grades, and can support their "principles" with numerous quotations, passing from Schweitzer's EMMA via Lasalle's IRON LAW OF WAGES, to Marx's CAPITAL, and still further.

In these loftier segments other categories of ideas, absent in these just described, begin gradually to appear—science and art, to which last belong also literature and music.

In science these men are positivists, only recognizing those things that can be weighed and measured. Anything beyond that they consider as rather discreditable nonsense, that same nonsense about which they held yesterday the theories that today are proven.

In art they are naturalists, which means that they recognize and value the personality, individuality and temperament of the artist up to a certain definite point. This point has been fixed by others, and in it they believe unflinchingly.

But despite their patent and well–ordered security, despite their infallible principles, there lurks in these higher segments a hidden fear, a nervous trembling, a sense of insecurity. And this is due to their upbringing. They know that the sages, statesmen and artists whom today they revere, were yesterday spurned as swindlers and charlatans. And the higher the segment in the triangle, the better defined is this fear, this modern sense of insecurity. Here and there are people with eyes which can see, minds which can correlate. They say to themselves: "If the science of the day before yesterday is rejected by the people of yesterday, and that of yesterday by us of today, is it not possible that what we call science now will be rejected by the men of tomorrow?" And the bravest of them answer, "It is possible."

Then people appear who can distinguish those problems that the science of today has not yet explained. And they ask themselves: "Will science, if it continues on the road it has followed for so long, ever attain to the solution of these problems? And if it does so attain, will men be able to rely on its solution?" In these segments are also professional men of learning who can remember the time when facts now recognized by the Academies as firmly established, were scorned by those same Academies. There are also philosophers of aesthetic who write profound books about an art which was yesterday condemned as nonsense. In writing these books they remove the barriers over which art has most recently stepped and set up new ones which are to remain for ever in the places they have chosen. They do not notice that they are busy erecting barriers, not in front of art, but behind it. And if they do notice this, on the morrow they merely write fresh books and hastily set their barriers a little further on. This performance will go on unaltered until it is realized that the most extreme principle of aesthetic can never be of value to the future, but only to the past. No such theory of principle can be laid down for those things which lie beyond, in the realm of the immaterial. That which has no material existence cannot be subjected to a material classification. That which belongs to the spirit of the future can only be realized in feeling, and to this feeling the talent of the artist is the only road. Theory is the lamp which sheds light on the petrified ideas of yesterday and of the more distant past. [Footnote: Cf. Chapter VII.] And as we rise higher in the triangle we find that the uneasiness increases, as a city built on the most correct architectural plan may be shaken suddenly by the uncontrollable force of nature. Humanity is living in such

a spiritual city, subject to these sudden disturbances for which neither architects nor mathematicians have made allowance. In one place lies a great wall crumbled to pieces like a card house, in another are the ruins of a huge tower which once stretched to heaven, built on many presumably immortal spiritual pillars. The abandoned churchyard quakes and forgotten graves open and from them rise forgotten ghosts. Spots appear on the sun and the sun grows dark, and what theory can fight with darkness? And in this city live also men deafened by false wisdom who hear no crash, and blinded by false wisdom, so that they say "our sun will shine more brightly than ever and soon the last spots will disappear." But sometime even these men will hear and see.

But when we get still higher there is no longer this bewilderment. There work is going on which boldly attacks those pillars which men have set up. There we find other professional men of learning who test matter again and again, who tremble before no problem, and who finally cast doubt on that very matter which was yesterday the foundation of everything, so that the whole universe is shaken. Every day another scientific theory finds bold discoverers who overstep the boundaries of prophecy and, forgetful of themselves, join the other soldiers in the conquest of some new summit and in the hopeless attack on some stubborn fortress. But "there is no fortress that man cannot overcome."

On the one hand, FACTS are being established which the science of yesterday dubbed swindles. Even newspapers, which are for the most part the most obsequious servants of worldly success and of the mob, and which trim their sails to every wind, find themselves compelled to modify their ironical judgements on the "marvels" of science and even to abandon them altogether. Various learned men, among them ultra–materialists, dedicate their strength to the scientific research of doubtful problems, which can no longer be lied about or passed over in silence. [FOOTNOTE: Zoller, Wagner, Butleroff (St. Petersburg), Crookes (London), etc.; later on, C. H. Richet, C. Flammarion. The Parisian paper Le Matin, published about two years ago the discoveries of the two last named under the title "Je le constate, mais je ne l'explique pas." Finally there are C. Lombroso, the inventor of the anthropological method of diagnosing crime, and Eusapio Palladino.]

On the other hand, the number is increasing of those men who put no trust in the methods of materialistic science when it deals with those questions which have to do with "non–matter," or matter which is not accessible to our minds. Just as art is looking for help from the primitives, so these men are turning to half–forgotten times in order to get

help from their half– forgotten methods. However, these very methods are still alive and in use among nations whom we, from the height of our knowledge, have been accustomed to regard with pity and scorn. To such nations belong the Indians, who from time to time confront those learned in our civilization with problems which we have either passed by unnoticed or brushed aside with superficial words and explanations. [FOOTNOTE: Frequently in such cases use is made of the word hypnotism; that same hypnotism which, in its earlier form of mesmerism, was disdainfully put aside by various learned bodies.] Mme. Blavatsky was the first person, after a life of many years in India, to see a connection between these "savages" and our "civilization." From that moment there began a tremendous spiritual movement which today includes a large number of people and has even assumed a material form in the THEOSOPHICAL SOCIETY. This society consists of groups who seek to approach the problem of the spirit by way of the INNER knowledge. The theory of Theosophy which serves as the basis to this movement was set out by Blavatsky in the form of a catechism in which the pupil receives definite answers to his questions from the theosophical point of view. [FOOTNOTE: E. P. Blavatsky, The Key of Theosophy, London, 1889.] Theosophy, according to Blavatsky, is synonymous with ETERNAL TRUTH. "The new torchbearer of truth will find the minds of men prepared for his message, a language ready for him in which to clothe the new truths he brings, an organization awaiting his arrival, which will remove the merely mechanical, material obstacles and difficulties from his path." And then Blavatsky continues: "The earth will be a heaven in the twenty–first century in comparison with what it is now," and with these words ends her book.

When religion, science and morality are shaken, the two last by the strong hand of Nietzsche, and when the outer supports threaten to fall, man turns his gaze from externals in on to himself. Literature, music and art are the first and most sensitive spheres in which this spiritual revolution makes itself felt. They reflect the dark picture of the present time and show the importance of what at first was only a little point of light noticed by few and for the great majority non–existent. Perhaps they even grow dark in their turn, but on the other hand they turn away from the soulless life of the present towards those substances and ideas which give free scope to the non–material strivings of the soul.

A poet of this kind in the realm of literature is Maeterlinck. He takes us into a world which, rightly or wrongly, we term supernatural. La Princesse Maleine, Les Sept Princesses, Les Aveugles, etc., are not people of past times as are the heroes in

Shakespeare. They are merely souls lost in the clouds, threatened by them with death, eternally menaced by some invisible and sombre power.

Spiritual darkness, the insecurity of ignorance and fear pervade the world in which they move. Maeterlinck is perhaps one of the first prophets, one of the first artistic reformers and seers to herald the end of the decadence just described. The gloom of the spiritual atmosphere, the terrible, but all–guiding hand, the sense of utter fear, the feeling of having strayed from the path, the confusion among the guides, all these are clearly felt in his works.[Footnote: To the front tank of such seers of the decadence belongs also Alfred Kubin. With irresistible force both Kubin's drawings and also his novel "Die Andere Seite" seem to engulf us in the terrible atmosphere of empty desolation.]

This atmosphere Maeterlinck creates principally by purely artistic means. His material machinery (gloomy mountains, moonlight, marshes, wind, the cries of owls, etc.) plays really a symbolic role and helps to give the inner note. [Footnote: When one of Maeterlinck's plays was produced in St. Petersburg under his own guidance, he himself at one of the rehearsals had a tower represented by a plain piece of hanging linen. It was of no importance to him to have elaborate scenery prepared. He did as children, the greatest imaginers of all time, always do in their games; for they use a stick for a horse or create entire regiments of cavalry out of chalks. And in the same way a chalk with a notch in it is changed from a knight into a horse. On similar lines the imagination of the spectator plays in the modern theatre, and especially in that of Russia, an important part. And this is a notable element in the transition from the material to the spiritual in the theatre of the future.] Maeterlinck's principal technical weapon is his use of words. The word may express an inner harmony. This inner harmony springs partly, perhaps principally, from the object which it names. But if the object is not itself seen, but only its name heard, the mind of the hearer receives an abstract impression only, that is to say as of the object dematerialized, and a corresponding vibration is immediately set up in the HEART.

The apt use of a word (in its poetical meaning), repetition of this word, twice, three times or even more frequently, according to the need of the poem, will not only tend to intensify the inner harmony but also bring to light unsuspected spiritual properties of the word itself. Further than that, frequent repetition of a word (again a favourite game of children, which is forgotten in after life) deprives the word of its original external meaning. Similarly, in drawing, the abstract message of the object drawn tends to be forgotten and its meaning lost. Sometimes perhaps we unconsciously hear this real

harmony sounding together with the material or later on with the non– material sense of the object. But in the latter case the true harmony exercises a direct impression on the soul. The soul undergoes an emotion which has no relation to any definite object, an emotion more complicated, I might say more super– sensuous than the emotion caused by the sound of a bell or of a stringed instrument. This line of development offers great possibilities to the literature of the future. In an embryonic form this word–power–has already been used in SERRES CHAUDES. [Footnote: SERRES CHAUDES, SUIVIES DE QUINZE CHANSONS, par Maurice Maeterlinck. Brussels. Lacomblez.] As Maeterlinck uses them, words which seem at first to create only a neutral impression have really a more subtle value. Even a familiar word like "hair," if used in a certain way can intensify an atmosphere of sorrow or despair. And this is Maeterlinck's method. He shows that thunder, lightning and a moon behind driving clouds, in themselves material means, can be used in the theatre to create a greater sense of terror than they do in nature.

The true inner forces do not lose their strength and effect so easily. [Footnote: A comparison between the work of Poe and Maeterlinck shows the course of artistic transition from the material to the abstract.] An the word which has two meanings, the first direct, the second indirect, is the pure material of poetry and of literature, the material which these arts alone can manipulate and through which they speak to the spirit.

Something similar may be noticed in the music of Wagner. His famous leitmotiv is an attempt to give personality to his characters by something beyond theatrical expedients and light effect. His method of using a definite motiv is a purely musical method. It creates a spiritual atmosphere by means of a musical phrase which precedes the hero, which he seems to radiate forth from any distance. [Footnote: Frequent attempts have shown that such a spiritual atmosphere can belong not only to heroes but to any human being. Sensitives cannot, for example, remain in a room in which a person has been who is spiritually antagonistic to them, even though they know nothing of his existence.] The most modern musicians like Debussy create a spiritual impression, often taken from nature, but embodied in purely musical form. For this reason Debussy is often classed with the Impressionist painters on the ground that he resembles these painters in using natural phenomena for the purposes of his art. Whatever truth there may be in this comparison merely accentuates the fact that the various arts of today learn from each other and often resemble each other. But it would be rash to say that this definition is an exhaustive statement of Debussy's significance. Despite his similarity with the

Impressionists this musician is deeply concerned with spiritual harmony, for in his works one hears the suffering and tortured nerves of the present time. And further Debussy never uses the wholly material note so characteristic of programme music, but trusts mainly in the creation of a more abstract impression. Debussy has been greatly influenced by Russian music, notably by Mussorgsky. So it is not surprising that he stands in close relation to the young Russian composers, the chief of whom is Scriabin. The experience of the hearer is frequently the same during the performance of the works of these two musicians. He is often snatched quite suddenly from a series of modern discords into the charm of more or less conventional beauty. He feels himself often insulted, tossed about like a tennis ball over the net between the two parties of the outer and the inner beauty. To those who are not accustomed to it the inner beauty appears as ugliness because humanity in general inclines to the outer and knows nothing of the inner. Almost alone in severing himself from conventional beauty is the Austrian composer, Arnold Schonberg. He says in his Harmonielehre: "Every combination of notes, every advance is possible, but I am beginning to feel that there are also definite rules and conditions which incline me to the use of this or that dissonance." [Footnote: "Die Musik," p. 104, from the Harmonielehre (Verlag der Universal Edition).] This means that Schonberg realizes that the greatest freedom of all, the freedom of an unfettered art, can never be absolute. Every age achieves a certain measure of this freedom, but beyond the boundaries of its freedom the mightiest genius can never go. But the measure of freedom of each age must be constantly enlarged. Schonberg is endeavouring to make complete use of his freedom and has already discovered gold mines of new beauty in his search for spiritual harmony. His music leads us into a realm where musical experience is a matter not of the ear but of the soul alone—and from this point begins the music of the future.

A parallel course has been followed by the Impressionist movement in painting. It is seen in its dogmatic and most naturalistic form in so-called Neo-Impressionism. The theory of this is to put on the canvas the whole glitter and brilliance of nature, and not only an isolated aspect of her.

It is interesting to notice three practically contemporary and totally different groups in painting. They are (1) Rossetti and his pupil Burne-Jones, with their followers; (2) Bocklin and his school; (3) Segantini, with his unworthy following of photographic artists. I have chosen these three groups to illustrate the search for the abstract in art. Rossetti sought to revive the non-materialism of the pre-Raphaelites. Bocklin busied himself with the mythological scenes, but was in contrast to Rossetti in that he gave

strongly material form to his legendary figures. Segantini, outwardly the most material of the three, selected the most ordinary objects (hills, stones, cattle, etc.) often painting them with the minutest realism, but he never failed to create a spiritual as well as a material value, so that really he is the most non–material of the trio.

These men sought for the "inner" by way of the "outer."

By another road, and one more purely artistic, the great seeker after a new sense of form approached the same problem. Cezanne made a living thing out of a teacup, or rather in a teacup he realized the existence of something alive. He raised still life to such a point that it ceased to be inanimate.

He painted these things as he painted human brings, because he was endowed with the gift of divining the inner life in everything. His colour and form are alike suitable to the spiritual harmony. A man, a tree, an apple, all were used by Cezanne in the creation of something that is called a "picture," and which is a piece of true inward and artistic harmony. The same intention actuates the work of one of the greatest of the young Frenchmen, Henri Matisse. He paints "pictures," and in these "pictures" endeavours to reproduce the divine.[Footnote: Cf. his article in KUNST UND KUNSTLER, 1909, No. 8.] To attain this end he requires as a starting point nothing but the object to be painted (human being or whatever it may be), and then the methods that belong to painting alone, colour and form.

By personal inclination, because he is French and because he is specially gifted as a colourist, Matisse is apt to lay too much stress on the colour. Like Debussy, he cannot always refrain from conventional beauty; Impressionism is in his blood. One sees pictures of Matisse which are full of great inward vitality, produced by the stress of the inner need, and also pictures which possess only outer charm, because they were painted on an outer impulse. (How often one is reminded of Manet in this.) His work seems to be typical French painting, with its dainty sense of melody, raised from time to time to the summit of a great hill above the clouds.

But in the work of another great artist in Paris, the Spaniard Pablo Picasso, there is never any suspicion of this conventional beauty. Tossed hither and thither by the need for self–expression, Picasso hurries from one manner to another. At times a great gulf appears between consecutive manners, because Picasso leaps boldly and is found continually by

his bewildered crowd of followers standing at a point very different from that at which they saw him last. No sooner do they think that they have reached him again than he has changed once more. In this way there arose Cubism, the latest of the French movements, which is treated in detail in Part II. Picasso is trying to arrive at constructiveness by way of proportion. In his latest works (1911) he has achieved the logical destruction of matter, not, however, by dissolution but rather by a kind of a parcelling out of its various divisions and a constructive scattering of these divisions about the canvas. But he seems in this most recent work distinctly desirous of keeping an appearance of matter. He shrinks from no innovation, and if colour seems likely to balk him in his search for a pure artistic form, he throws it overboard and paints a picture in brown and white; and the problem of purely artistic form is the real problem of his life.

In their pursuit of the same supreme end Matisse and Picasso stand side by side, Matisse representing colour and Picasso form.

IV. THE PYRAMID

And so at different points along the road are the different arts, saying what they are best able to say, and in the language which is peculiarly their own. Despite, or perhaps thanks to, the differences between them, there has never been a time when the arts approached each other more nearly than they do today, in this later phase of spiritual development.

In each manifestation is the seed of a striving towards the abstract, the non-material. Consciously or unconsciously they are obeying Socrates' command—Know thyself. Consciously or unconsciously artists are studying and proving their material, setting in the balance the spiritual value of those elements, with which it is their several privilege to work.

And the natural result of this striving is that the various arts are drawing together. They are finding in Music the best teacher. With few exceptions music has been for some centuries the art which has devoted itself not to the reproduction of natural phenomena, but rather to the expression of the artist's soul, in musical sound.

A painter, who finds no satisfaction in mere representation, however artistic, in his longing to express his inner life, cannot but envy the ease with which music, the most

non—material of the arts today, achieves this end. He naturally seeks to apply the methods of music to his own art. And from this results that modern desire for rhythm in painting, for mathematical, abstract construction, for repeated notes of colour, for setting colour in motion.

This borrowing of method by one art from another, can only be truly successful when the application of the borrowed methods is not superficial but fundamental. One art must learn first how another uses its methods, so that the methods may afterwards be applied to the borrower's art from the beginning, and suitably. The artist must not forget that in him lies the power of true application of every method, but that that power must be developed.

In manipulation of form music can achieve results which are beyond the reach of painting. On the other hand, painting is ahead of music in several particulars. Music, for example, has at its disposal duration of time; while painting can present to the spectator the whole content of its message at one moment. [Footnote: These statements of difference are, of course, relative; for music can on occasions dispense with extension of time, and painting make use of it.] Music, which is outwardly unfettered by nature, needs no definite form for its expression.

[Footnote: How miserably music fails when attempting to express material appearances is proved by the affected absurdity of programme music. Quite lately such experiments have been made. The imitation in sound of croaking frogs, of farmyard noises, of household duties, makes an excellent music hall turn and is amusing enough. But in serious music such attempts are merely warnings against any imitation of nature. Nature has her own language, and a powerful one; this language cannot be imitated. The sound of a farmyard in music is never successfully reproduced, and is unnecessary waste of time. The Stimmung of nature can be imparted by every art, not, however, by imitation, but by the artistic divination of its inner spirit.]

Painting today is almost exclusively concerned with the reproduction of natural forms and phenomena. Her business is now to test her strength and methods, to know herself as music has done for a long time, and then to use her powers to a truly artistic end.

And so the arts are encroaching one upon another, and from a proper use of this encroachment will rise the art that is truly monumental. Every man who steeps himself in

the spiritual possibilities of his art is a valuable helper in the building of the spiritual pyramid which will some day reach to heaven.

PART II: ABOUT PAINTING

V. THE PSHCHOLOGICAL WORKING OF COLOUR

To let the eye stray over a palette, splashed with many colours, produces a dual result. In the first place one receives a PURELY PHYSICAL IMPRESSION, one of pleasure and contentment at the varied and beautiful colours. The eye is either warmed or else soothed and cooled. But these physical sensations can only be of short duration. They are merely superficial and leave no lasting impression, for the soul is unaffected. But although the effect of the colours is forgotten when the eye is turned away, the superficial impression of varied colour may be the starting point of a whole chain of related sensations.

On the average man only the impressions caused by very familiar objects, will be purely superficial. A first encounter with any new phenomenon exercises immediately an impression on the soul. This is the experience of the child discovering the world, to whom every object is new. He sees a light, wishes to take hold of it, burns his finger and feels henceforward a proper respect for flame. But later he learns that light has a friendly as well as an unfriendly side, that it drives away the darkness, makes the day longer, is essential to warmth, cooking, play–acting. From the mass of these discoveries is composed a knowledge of light, which is indelibly fixed in his mind. The strong, intensive interest disappears and the various properties of flame are balanced against each other. In this way the whole world becomes gradually disenchanted. It is realized that trees give shade, that horses run fast and motor–cars still faster, that dogs bite, that the figure seen in a mirror is not a real human being.

As the man develops, the circle of these experiences caused by different beings and objects, grows ever wider. They acquire an inner meaning and eventually a spiritual harmony. It is the same with colour, which makes only a momentary and superficial impression on a soul but slightly developed in sensitiveness. But even this superficial impression varies in quality. The eye is strongly attracted by light, clear colours, and still more strongly attracted by those colours which are warm as well as clear; vermilion has the charm of flame, which has always attracted human beings. Keen lemon–yellow hurts

the eye in time as a prolonged and shrill trumpet–note the ear, and the gazer turns away to seek relief in blue or green.

But to a more sensitive soul the effect of colours is deeper and intensely moving. And so we come to the second main result of looking at colours: THEIR PSYCHIC EFFECT. They produce a corresponding spiritual vibration, and it is only as a step towards this spiritual vibration that the elementary physical impression is of importance.

Whether the psychic effect of colour is a direct one, as these last few lines imply, or whether it is the outcome of association, is perhaps open to question. The soul being one with the body, the former may well experience a psychic shock, caused by association acting on the latter. For example, red may cause a sensation analogous to that caused by flame, because red is the colour of flame. A warm red will prove exciting, another shade of red will cause pain or disgust through association with running blood. In these cases colour awakens a corresponding physical sensation, which undoubtedly works upon the soul.

If this were always the case, it would be easy to define by association the effects of colour upon other senses than that of sight. One might say that keen yellow looks sour, because it recalls the taste of a lemon.

But such definitions are not universally possible. There are many examples of colour working which refuse to be so classified. A Dresden doctor relates of one of his patients, whom he designates as an "exceptionally sensitive person," that he could not eat a certain sauce without tasting "blue," i.e. without experiencing a feeling of seeing a blue color. [Footnote: Dr. Freudenberg. "Spaltung der Personlichkeit" (Ubersinnliche Welt. 1908. No. 2, p. 64–65). The author also discusses the hearing of colour, and says that here also no rules can be laid down. But cf. L. Sabanejeff in "Musik," Moscow, 1911, No. 9, where the imminent possibility of laying down a law is clearly hinted at.] It would be possible to suggest, by way of explanation of this, that in highly sensitive people, the way to the soul is so direct and the soul itself so impressionable, that any impression of taste communicates itself immediately to the soul, and thence to the other organs of sense (in this case, the eyes). This would imply an echo or reverberation, such as occurs sometimes in musical instruments which, without being touched, sound in harmony with some other instrument struck at the moment.

But not only with taste has sight been known to work in harmony. Many colours have been described as rough or sticky, others as smooth and uniform, so that one feels inclined to stroke them (e.g., dark ultramarine, chromic oxide green, and rose madder). Equally the distinction between warm and cold colours belongs to this connection. Some colours appear soft (rose madder), others hard (cobalt green, blue–green oxide), so that even fresh from the tube they seem to be dry.

The expression "scented colours" is frequently met with. And finally the sound of colours is so definite that it would be hard to find anyone who would try to express bright yellow in the bass notes, or dark lake in the treble.

[Footnote: Much theory and practice have been devoted to this question. People have sought to paint in counterpoint. Also unmusical children have been successfully helped to play the piano by quoting a parallel in colour (e.g., of flowers). On these lines Frau A. Sacharjin–Unkowsky has worked for several years and has evolved a method of "so describing sounds by natural colours, and colours by natural sounds, that colour could be heard and sound seen." The system has proved successful for several years both in the inventor's own school and the Conservatoire at St. Petersburg. Finally Scriabin, on more spiritual lines, has paralleled sound and colours in a chart not unlike that of Frau Unkowsky. In "Prometheus" he has given convincing proof of his theories. (His chart appeared in "Musik," Moscow, 1911, No. 9.)]

[Footnote: The converse question, i.e. the colour of sound, was touched upon by Mallarme and systematized by his disciple Rene Ghil, whose book, Traite du Verbe, gives the rules for "l'instrumentation verbale."—M.T.H.S.]

The explanation by association will not suffice us in many, and the most important cases. Those who have heard of chromotherapy will know that coloured light can exercise very definite influences on the whole body. Attempts have been made with different colours in the treatment of various nervous ailments. They have shown that red light stimulates and excites the heart, while blue light can cause temporary paralysis. But when the experiments come to be tried on animals and even plants, the association theory falls to the ground. So one is bound to admit that the question is at present unexplored, but that colour can exercise enormous influence over the body as a physical organism.

No more sufficient, in the psychic sphere, is the theory of association. Generally speaking, colour is a power which directly influences the soul. Colour is the keyboard, the eyes are the hammers, the soul is the piano with many strings. The artist is the hand which plays, touching one key or another, to cause vibrations in the soul.

IT IS EVIDENT THEREFORE THAT COLOUR HARMONY MUST REST ONLY ON A CORRESPONDING VIBRATION IN THE HUMAN SOUL; AND THIS IS ONE OF THE GUIDING PRINCIPLES OF THE INNER NEED.

[Footnote: The phrase "inner need" (innere Notwendigkeit) means primarily the impulse felt by the artist for spiritual expression. Kandinsky is apt, however, to use the phrase sometimes to mean not only the hunger for spiritual expression, but also the actual expression itself.—M.T.H.S.]

VI. THE LANGUAGE OF FORM AND COLOUR

The man that hath no music in himself, Nor is not mov'd with concord of sweet sounds, Is fit for treasons, stratagems, and spoils; The motions of his spirit are dull as night, And his affections dark as Erebus: Let no such man be trusted. Mark the music. (The Merchant of Venice, Act v, Scene I.)

Musical sound acts directly on the soul and finds an echo there because, though to varying extents, music is innate in man. [Footnote: Cf. E. Jacques–Dalcroze in The Eurhythmics of Jacques– Dalcroze. London, Constable.—M.T.H.S.]

"Everyone knows that yellow, orange, and red suggest ideas of joy and plenty" (Delacroix). [Footnote: Cf. Paul Signac, D'Eugene Delacroix au Neo–Impressionisme. Paris. Floury. Also compare an interesting article by K. Schettler: "Notizen uber die Farbe." (Decorative Kunst, 1901, February).]

These two quotations show the deep relationship between the arts, and especially between music and painting. Goethe said that painting must count this relationship her main foundation, and by this prophetic remark he seems to foretell the position in which painting is today. She stands, in fact, at the first stage of the road by which she will, according to her own possibilities, make art an abstraction of thought and arrive finally at

purely artistic composition. [Footnote: By "Komposition" Kandinsky here means, of course, an artistic creation. He is not referring to the arrangement of the objects in a picture.—M.T.H.S.]

Painting has two weapons at her disposal:

```
1. Colour.
2. Form.
```

Form can stand alone as representing an object (either real or otherwise) or as a purely abstract limit to a space or a surface.

Colour cannot stand alone; it cannot dispense with boundaries of some kind. [Footnote: Cf. A. Wallace Rimington. Colour music (OP. CIT.) where experiments are recounted with a colour organ, which gives symphonies of rapidly changing colour without boundaries— except the unavoidable ones of the white curtain on which the colours are reflected.—M.T.H.S.] A never-ending extent of red can only be seen in the mind; when the word red is heard, the colour is evoked without definite boundaries. If such are necessary they have deliberately to be imagined. But such red, as is seen by the mind and not by the eye, exercises at once a definite and an indefinite impression on the soul, and produces spiritual harmony. I say "indefinite," because in itself it has no suggestion of warmth or cold, such attributes having to be imagined for it afterwards, as modifications of the original "redness." I say "definite," because the spiritual harmony exists without any need for such subsequent attributes of warmth or cold. An analogous case is the sound of a trumpet which one hears when the word "trumpet" is pronounced. This sound is audible to the soul, without the distinctive character of a trumpet heard in the open air or in a room, played alone or with other instruments, in the hands of a postilion, a huntsman, a soldier, or a professional musician.

But when red is presented in a material form (as in painting) it must possess (1) some definite shade of the many shades of red that exist and (2) a limited surface, divided off from the other colours, which are undoubtedly there. The first of these conditions (the subjective) is affected by the second (the objective), for the neighbouring colours affect the shade of red.

This essential connection between colour and form brings us to the question of the influences of form on colour. Form alone, even though totally abstract and geometrical, has a power of inner suggestion. A triangle (without the accessory consideration of its being acute–or obtuse–angled or equilateral) has a spiritual value of its own. In connection with other forms, this value may be somewhat modified, but remains in quality the same. The case is similar with a circle, a square, or any conceivable geometrical figure. [Footnote: The angle at which the triangle stands, and whether it is stationary or moving, are of importance to its spiritual value. This fact is specially worthy of the painter's consideration.] As above, with the red, we have here a subjective substance in an objective shell.

The mutual influence of form and colour now becomes clear. A yellow triangle, a blue circle, a green square, or a green triangle, a yellow circle, a blue square—all these are different and have different spiritual values.

It is evident that many colours are hampered and even nullified in effect by many forms. On the whole, keen colours are well suited by sharp forms (e.g., a yellow triangle), and soft, deep colours by round forms (e.g., a blue circle). But it must be remembered that an unsuitable combination of form and colour is not necessarily discordant, but may, with manipulation, show the way to fresh possibilities of harmony.

Since colours and forms are well–nigh innumerable, their combination and their influences are likewise unending. The material is inexhaustible.

Form, in the narrow sense, is nothing but the separating line between surfaces of colour. That is its outer meaning. But it has also an inner meaning, of varying intensity, [Footnote: It is never literally true that any form is meaningless and "says nothing." Every form in the world says something. But its message often fails to reach us, and even if it does, full understanding is often withheld from us.] and, properly speaking, FORM IS THE OUTWARD EXPRESSION OF THIS INNER MEANING. To use once more the metaphor of the piano—the artist is the hand which, by playing on this or that key (i.e., form), affects the human soul in this or that way. SO IT IS EVIDENT THAT FORM–HARMONY MUST REST ONLY ON A CORRESPONDING VIBRATION OF THE HUMAN SOUL; AND THIS IS A SECOND GUIDING PRINCIPLE OF THE INNER NEED.

Concerning the Spiritual in Art

The two aspects of form just mentioned define its two aims. The task of limiting surfaces (the outer aspect) is well performed if the inner meaning is fully expressed.

[Footnote: The phrase "full expression" must be clearly understood. Form often is most expressive when least coherent. It is often most expressive when outwardly most imperfect, perhaps only a stroke, a mere hint of outer meaning.]

The outer task may assume many different shapes; but it will never fail in one of two purposes: (1) Either form aims at so limiting surfaces as to fashion of them some material object; (2) Or form remains abstract, describing only a non–material, spiritual entity. Such non–material entities, with life and value as such, are a circle, a triangle, a rhombus, a trapeze, etc., many of them so complicated as to have no mathematical denomination.

Between these two extremes lie the innumerable forms in which both elements exist; with a preponderance either of the abstract or the material. These intermediate forms are, at present, the store on which the artist has to draw. Purely abstract forms are beyond the reach of the artist at present; they are too indefinite for him. To limit himself to the purely indefinite would be to rob himself of possibilities, to exclude the human element and therefore to weaken his power of expression.

On the other hand, there exists equally no purely material form. A material object cannot be absolutely reproduced. For good or evil, the artist has eyes and hands, which are perhaps more artistic than his intentions and refuse to aim at photography alone. Many genuine artists, who cannot be content with a mere inventory of material objects, seek to express the objects by what was once called "idealization," then "selection," and which tomorrow will again be called something different.

[Footnote: The motive of idealization is so to beautify the organic form as to bring out its harmony and rouse poetic feeling. "Selection" aims not so much at beautification as at emphasizing the character of the object, by the omission of non– essentials. The desire of the future will be purely the expression of the inner meaning. The organic form no longer serves as direct object, but as the human words in which a divine message must be written, in order for it to be comprehensible to human minds.]

The impossibility and, in art, the uselessness of attempting to copy an object exactly, the desire to give the object full expression, are the impulses which drive the artist away from

"literal" colouring to purely artistic aims. And that brings us to the question of composition. [FOOTNOTE: Here Kandinsky means arrangement of the picture.—M.T.H.S.]

Pure artistic composition has two elements:

1. The composition of the whole picture.

2. The creation of the various forms which, by standing in different relationships to each other, decide the composition of the whole. [Footnote: The general composition will naturally include many little compositions which may be antagonistic to each other, though helping—perhaps by their very antagonism—the harmony of the whole. These little compositions have themselves subdivisions of varied inner meanings.] Many objects have to be considered in the light of the whole, and so ordered as to suit this whole. Singly they will have little meaning, being of importance only in so far as they help the general effect. These single objects must be fashioned in one way only; and this, not because their own inner meaning demands that particular fashioning, but entirely because they have to serve as building material for the whole composition. [Footnote: A good example is Cezanne's "Bathing Women," which is built in the form of a triangle. Such building is an old principle, which was being abandoned only because academic usage had made it lifeless. But Cezanne has given it new life. He does not use it to harmonize his groups, but for purely artistic purposes. He distorts the human figure with perfect justification. Not only must the whole figure follow the lines of the triangle, but each limb must grow narrower from bottom to top. Raphael's "Holy Family" is an example of triangular composition used only for the harmonizing of the group, and without any mystical motive.]

So the abstract idea is creeping into art, although, only yesterday, it was scorned and obscured by purely material ideals. Its gradual advance is natural enough, for in proportion as the organic form falls into the background, the abstract ideal achieves greater prominence.

But the organic form possesses all the same an inner harmony of its own, which may be either the same as that of its abstract parallel (thus producing a simple combination of the two elements) or totally different (in which case the combination may be unavoidably discordant). However diminished in importance the organic form may be, its inner note

will always be heard; and for this reason the choice of material objects is an important one. The spiritual accord of the organic with the abstract element may strengthen the appeal of the latter (as much by contrast as by similarity) or may destroy it.

Suppose a rhomboidal composition, made up of a number of human figures. The artist asks himself: Are these human figures an absolute necessity to the composition, or should they be replaced by other forms, and that without affecting the fundamental harmony of the whole? If the answer is "Yes," we have a case in which the material appeal directly weakens the abstract appeal. The human form must either be replaced by another object which, whether by similarity or contrast, will strengthen the abstract appeal, or must remain a purely non-material symbol. [Footnote: Cf. Translator's Introduction, pp. xviii and xx.—M.T.H.S.]

Once more the metaphor of the piano. For "colour" or "form" substitute "object." Every object has its own life and therefore its own appeal; man is continually subject to these appeals. But the results are often dubbed either sub—or super—conscious. Nature, that is to say the ever—changing surroundings of man, sets in vibration the strings of the piano (the soul) by manipulation of the keys (the various objects with their several appeals).

The impressions we receive, which often appear merely chaotic, consist of three elements: the impression of the colour of the object, of its form, and of its combined colour and form, i.e. of the object itself.

At this point the individuality of the artist comes to the front and disposes, as he wills, these three elements. IT IS CLEAR, THEREFORE, THAT THE CHOICE OF OBJECT (i.e. OF ONE OF THE ELEMENTS IN THE HARMONY OF FORM) MUST BE DECIDED ONLY BY A CORRESPONDING VIBRATION IN THE HUMAN SOUL; AND THIS IS A THIRD GUIDING PRINCIPLE OF THE INNER NEED.

The more abstract is form, the more clear and direct is its appeal. In any composition the material side may be more or less omitted in proportion as the forms used are more or less material, and for them substituted pure abstractions, or largely dematerialized objects. The more an artist uses these abstracted forms, the deeper and more confidently will he advance into the kingdom of the abstract. And after him will follow the gazer at his pictures, who also will have gradually acquired a greater familiarity with the language of that kingdom.

Concerning the Spiritual in Art

Must we then abandon utterly all material objects and paint solely in abstractions? The problem of harmonizing the appeal of the material and the non−material shows us the answer to this question. As every word spoken rouses an inner vibration, so likewise does every object represented. To deprive oneself of this possibility is to limit one's powers of expression. That is at any rate the case at present. But besides this answer to the question, there is another, and one which art can always employ to any question beginning with "must": There is no "must" in art, because art is free.

With regard to the second problem of composition, the creation of the single elements which are to compose the whole, it must be remembered that the same form in the same circumstances will always have the same inner appeal. Only the circumstances are constantly varying. It results that: (1) The ideal harmony alters according to the relation to other forms of the form which causes it. (2) Even in similar relationship a slight approach to or withdrawal from other forms may affect the harmony. [FOOTNOTE: This is what is meant by "an appeal of motion." For example, the appeal of an upright triangle is more steadfast and quiet than that of one set obliquely on its side.] Nothing is absolute. Form−composition rests on a relative basis, depending on (1) the alterations in the mutual relations of forms one to another, (2) alterations in each individual form, down to the very smallest. Every form is as sensitive as a puff of smoke, the slightest breath will alter it completely. This extreme mobility makes it easier to obtain similar harmonies from the use of different forms, than from a repetition of the same one; though of course an exact replica of a spiritual harmony can never be produced. So long as we are susceptible only to the appeal of a whole composition, this fact is of mainly theoretical importance. But when we become more sensitive by a constant use of abstract forms (which have no material interpretation) it will become of great practical significance. And so as art becomes more difficult, its wealth of expression in form becomes greater and greater. At the same time the question of distortion in drawing falls out and is replaced by the question how far the inner appeal of the particular form is veiled or given full expression. And once more the possibilities are extended, for combinations of veiled and fully expressed appeals suggest new LEITMOTIVEN in composition.

Without such development as this, form−composition is impossible. To anyone who cannot experience the inner appeal of form (whether material or abstract) such composition can never be other than meaningless. Apparently aimless alterations in form−arrangement will make art seem merely a game. So once more we are faced with the same principle, which is to set art free, the principle of the inner need.

Concerning the Spiritual in Art

When features or limbs for artistic reasons are changed or distorted, men reject the artistic problem and fall back on the secondary question of anatomy. But, on our argument, this secondary consideration does not appear, only the real, artistic question remaining. These apparently irresponsible, but really well–reasoned alterations in form provide one of the storehouses of artistic possibilities.

The adaptability of forms, their organic but inward variations, their motion in the picture, their inclination to material or abstract, their mutual relations, either individually or as parts of a whole; further, the concord or discord of the various elements of a picture, the handling of groups, the combinations of veiled and openly expressed appeals, the use of rhythmical or unrhythmical, of geometrical or non–geometrical forms, their contiguity or separation—all these things are the material for counterpoint in painting.

But so long as colour is excluded, such counterpoint is confined to black and white. Colour provides a whole wealth of possibilities of her own, and when combined with form, yet a further series of possibilities. And all these will be expressions of the inner need.

The inner need is built up of three mystical elements: (1) Every artist, as a creator, has something in him which calls for expression (this is the element of personality). (2) Every artist, as child of his age, is impelled to express the spirit of his age (this is the element of style)—dictated by the period and particular country to which the artist belongs (it is doubtful how long the latter distinction will continue to exist). (3) Every artist, as a servant of art, has to help the cause of art (this is the element of pure artistry, which is constant in all ages and among all nationalities).

A full understanding of the first two elements is necessary for a realization of the third. But he who has this realization will recognize that a rudely carved Indian column is an expression of the same spirit as actuates any real work of art of today.

In the past and even today much talk is heard of "personality" in art. Talk of the coming "style" becomes more frequent daily. But for all their importance today, these questions will have disappeared after a few hundred or thousand years.

Only the third element—that of pure artistry—will remain for ever. An Egyptian carving speaks to us today more subtly than it did to its chronological contemporaries; for they

judged it with the hampering knowledge of period and personality. But we can judge purely as an expression of the eternal artistry.

Similarly—the greater the part played in a modern work of art by the two elements of style and personality, the better will it be appreciated by people today; but a modern work of art which is full of the third element, will fail to reach the contemporary soul. For many centuries have to pass away before the third element can be received with understanding. But the artist in whose work this third element predominates is the really great artist.

Because the elements of style and personality make up what is called the periodic characteristics of any work of art, the "development" of artistic forms must depend on their separation from the element of pure artistry, which knows neither period nor nationality. But as style and personality create in every epoch certain definite forms, which, for all their superficial differences, are really closely related, these forms can be spoken of as one side of art—the SUBJECTIVE. Every artist chooses, from the forms which reflect his own time, those which are sympathetic to him, and expresses himself through them. So the subjective element is the definite and external expression of the inner, objective element.

The inevitable desire for outward expression of the OBJECTIVE element is the impulse here defined as the "inner need." The forms it borrows change from day to day, and, as it continually advances, what is today a phrase of inner harmony becomes tomorrow one of outer harmony. It is clear, therefore, that the inner spirit of art only uses the outer form of any particular period as a stepping–stone to further expression.

In short, the working of the inner need and the development of art is an ever–advancing expression of the eternal and objective in the terms of the periodic and subjective.

Because the objective is forever exchanging the subjective expression of today for that of tomorrow, each new extension of liberty in the use of outer form is hailed as the last and supreme. At present we say that an artist can use any form he wishes, so long as he remains in touch with nature. But this limitation, like all its predecessors, is only temporary. From the point of view of the inner need, no limitation must be made. The artist may use any form which his expression demands; for his inner impulse must find suitable outward expression.

Concerning the Spiritual in Art

So we see that a deliberate search for personality and "style" is not only impossible, but comparatively unimportant. The close relationship of art throughout the ages, is not a relationship in outward form but in inner meaning. And therefore the talk of schools, of lines of "development," of "principles of art," etc., is based on misunderstanding and can only lead to confusion.

The artist must be blind to distinctions between "recognized" or "unrecognized" conventions of form, deaf to the transitory teaching and demands of his particular age. He must watch only the trend of the inner need, and hearken to its words alone. Then he will with safety employ means both sanctioned and forbidden by his contemporaries. All means are sacred which are called for by the inner need. All means are sinful which obscure that inner need.

It is impossible to theorize about this ideal of art. In real art theory does not precede practice, but follows her. Everything is, at first, a matter of feeling. Any theoretical scheme will be lacking in the essential of creation—the inner desire for expression—which cannot be determined. Neither the quality of the inner need, nor its subjective form, can be measured nor weighed.

[Footnote: The many-sided genius of Leonardo devised a system of little spoons with which different colours were to be used, thus creating a kind of mechanical harmony. One of his pupils, after trying in vain to use this system, in despair asked one of his colleagues how the master himself used the invention. The colleague replied: "The master never uses it at all." (Mereschowski, LEONARDO DA VINCI).]

Such a grammar of painting can only be temporarily guessed at, and should it ever be achieved, it will be not so much according to physical rules (which have so often been tried and which today the Cubists are trying) as according to the rules of the inner need, which are of the soul.

The inner need is the basic alike of small and great problems in painting. We are seeking today for the road which is to lead us away from the outer to the inner basis.

[Footnote: The term "outer," here used, must not be confused with the term "material" used previously. I am using the former to mean "outer need," which never goes beyond conventional limits, nor produces other than conventional beauty. The "inner need"

knows no such limits, and often produces results conventionally considered "ugly." But "ugly" itself is a conventional term, and only means "spiritually unsympathetic," being applied to some expression of an inner need, either outgrown or not yet attained. But everything which adequately expresses the inner need is beautiful.]

The spirit, like the body, can be strengthened and developed by frequent exercise. Just as the body, if neglected, grows weaker and finally impotent, so the spirit perishes if untended. And for this reason it is necessary for the artist to know the starting point for the exercise of his spirit.

The starting point is the study of colour and its effects on men.

There is no need to engage in the finer shades of complicated colour, but rather at first to consider only the direct use of simple colours.

To begin with, let us test the working on ourselves of individual colours, and so make a simple chart, which will facilitate the consideration of the whole question.

Two great divisions of colour occur to the mind at the outset: into warm and cold, and into light and dark. To each colour there are therefore four shades of appeal—warm and light or warm and dark, or cold and light or cold and dark.

Generally speaking, warmth or cold in a colour means an approach respectively to yellow or to blue. This distinction is, so to speak, on one basis, the colour having a constant fundamental appeal, but assuming either a more material or more non-material quality. The movement is an horizontal one, the warm colours approaching the spectator, the cold ones retreating from him.

The colours, which cause in another colour this horizontal movement, while they are themselves affected by it, have another movement of their own, which acts with a violent separative force. This is, therefore, the first antithesis in the inner appeal, and the inclination of the colour to yellow or to blue, is of tremendous importance.

The second antithesis is between white and black; i.e., the inclination to light or dark caused by the pair of colours just mentioned. These colours have once more their peculiar movement to and from the spectator, but in a more rigid form (see Fig. 1).

FIGURE I

```
First Pair of antitheses.           (inner appeal acting on
     A and B.                              the spirit)

A.      Warm            Cold
        Yellow          Blue        = First antithesis

Two movements:

        (i) horizontal

Towards the spectator [——-{{{ }}}——-] Away from the spectator
    (bodily)                               (spiritual)

                      Yellow      Blue

     (ii)           Ex-       and       concentric

B.   Light                Dark
     White                Black         = Second Antithesis

Two movements:

     (i) discordant

Eternal discord, but with              Absolute discord, devoid
 possibilities for the    White  Black of possibilities for the
     future (birth)                        future (death)

    (ii) ex-and concentric, as in case of yellow and blue, but
         more rigid.
```

Yellow and blue have another movement which affects the first antithesis—an ex–and concentric movement. If two circles are drawn and painted respectively yellow and blue, brief concentration will reveal in the yellow a spreading movement out from the centre, and a noticeable approach to the spectator. The blue, on the other hand, moves in upon

itself, like a snail retreating into its shell, and draws away from the spectator. [Footnote: These statements have no scientific basis, but are founded purely on spiritual experience.]

In the case of light and dark colours the movement is emphasized. That of the yellow increases with an admixture of white, i.e., as it becomes lighter. That of the blue increases with an admixture of black, i.e., as it becomes darker. This means that there can never be a dark-coloured yellow. The relationship between white and yellow is as close as between black and blue, for blue can be so dark as to border on black. Besides this physical relationship, is also a spiritual one (between yellow and white on one side, between blue and black on the other) which marks a strong separation between the two pairs.

An attempt to make yellow colder produces a green tint and checks both the horizontal and excentric movement. The colour becomes sickly and unreal. The blue by its contrary movement acts as a brake on the yellow, and is hindered in its own movement, till the two together become stationary, and the result is green. Similarly a mixture of black and white produces gray, which is motionless and spiritually very similar to green.

But while green, yellow, and blue are potentially active, though temporarily paralysed, in gray there is no possibility of movement, because gray consists of two colours that have no active force, for they stand the, one in motionless discord, the other in a motionless negation, even of discord, like an endless wall or a bottomless pit.

Because the component colours of green are active and have a movement of their own, it is possible, on the basis of this movement, to reckon their spiritual appeal.

The first movement of yellow, that of approach to the spectator (which can be increased by an intensification of the yellow), and also the second movement, that of over-spreading the boundaries, have a material parallel in the human energy which assails every obstacle blindly, and bursts forth aimlessly in every direction.

Yellow, if steadily gazed at in any geometrical form, has a disturbing influence, and reveals in the colour an insistent, aggressive character. [Footnote: It is worth noting that the sour-tasting lemon and shrill-singing canary are both yellow.] The intensification of the yellow increases the painful shrillness of its note.

[FOOTNOTE: Any parallel between colour and music can only be relative. Just as a violin can give various shades of tone,—so yellow has shades, which can be expressed by various instruments. But in making such parallels, I am assuming in each case a pure tone of colour or sound, unvaried by vibration or dampers, etc.]

Yellow is the typically earthly colour. It can never have profound meaning. An intermixture of blue makes it a sickly colour. It may be paralleled in human nature, with madness, not with melancholy or hypochondriacal mania, but rather with violent raving lunacy.

The power of profound meaning is found in blue, and first in its physical movements (1) of retreat from the spectator, (2) of turning in upon its own centre. The inclination of blue to depth is so strong that its inner appeal is stronger when its shade is deeper.

Blue is the typical heavenly colour.

[FOOTNOTE: ...The halos are golden for emperors and prophets (i.e. for mortals), and sky–blue for symbolic figures (i.e. spiritual beings); (Kondakoff, Histoire de I'An Byzantine consideree principalement dans les miniatures, vol. ii, p. 382, Paris, 1886–91).]

The ultimate feeling it creates is one of rest.

[FOOTNOTE: Supernatural rest, not the earthly contentment of green. The way to the supernatural lies through the natural. And we mortals passing from the earthly yellow to the heavenly blue must pass through green.]

When it sinks almost to black, it echoes a grief that is hardly human.

[FOOTNOTE: As an echo of grief violet stand to blue as does green in its production of rest.]

When it rises towards white, a movement little suited to it, its appeal to men grows weaker and more distant. In music a light blue is like a flute, a darker blue a cello; a still darker a thunderous double bass; and the darkest blue of all–an organ.

A well-balanced mixture of blue and yellow produces green. The horizontal movement ceases; likewise that from and towards the centre. The effect on the soul through the eye is therefore motionless. This is a fact recognized not only by opticians but by the world. Green is the most restful colour that exists. On exhausted men this restfulness has a beneficial effect, but after a time it becomes wearisome. Pictures painted in shades of green are passive and tend to be wearisome; this contrasts with the active warmth of yellow or the active coolness of blue. In the hierarchy of colours green is the "bourgeoisie"-self-satisfied, immovable, narrow. It is the colour of summer, the period when nature is resting from the storms of winter and the productive energy of spring (of. Fig. 2).

Any preponderance in green of yellow or blue introduces a corresponding activity and changes the inner appeal. The green keeps its characteristic equanimity and restfulness, the former increasing with the inclination to lightness, the latter with the inclination to depth. In music the absolute green is represented by the placid, middle notes of a violin.

Black and white have already been discussed in general terms. More particularly speaking, white, although often considered as no colour (a theory largely due to the Impressionists, who saw no white in nature as a symbol of a world from which all colour as a definite attribute has disappeared).

[FOOTNOTE: Van Gogh, in his letters, asks whether he may not paint a white wall dead white. This question offers no difficulty to the non-representative artist who is concerned only with the inner harmony of colour. But to the impressionist-realist it seems a bold liberty to take with nature. To him it seems as outrageous as his own change from brown shadows to blue seemed to his contemporaries. Van Gogh's question marks a transition from Impressionism to an art of spiritual harmony, as the coming of the blue shadow marked a transition from academism to Impressionism. (Cf. The Letters of Vincent van Gogh. Constable, London.)]

This world is too far above us for its harmony to touch our souls. A great silence, like an impenetrable wall, shrouds its life from our understanding. White, therefore, has this harmony of silence, which works upon us negatively, like many pauses in music that break temporarily the melody. It is not a dead silence, but one pregnant with possibilities. White has the appeal of the nothingness that is before birth, of the world in the ice age.

A totally dead silence, on the other hand, a silence with no possibilities, has the inner harmony of black. In music it is represented by one of those profound and final pauses, after which any continuation of the melody seems the dawn of another world. Black is something burnt out, like the ashes of a funeral pyre, something motionless like a corpse. The silence of black is the silence of death. Outwardly black is the colour with least harmony of all, a kind of neutral background against which the minutest shades of other colours stand clearly forward. It differs from white in this also, for with white nearly every colour is in discord, or even mute altogether.

[FOOTNOTE: E.g. vermilion rings dull and muddy against white, but against black with clear strength. Light yellow against white is weak, against black pure and brilliant.]

Not without reason is white taken as symbolizing joy and spotless purity, and black grief and death. A blend of black and white produces gray which, as has been said, is silent and motionless, being composed of two inactive colours, its restfulness having none of the potential activity of green. A similar gray is produced by a mixture of green and red, a spiritual blend of passivity and glowing warmth.

[FOOTNOTE: Gray = immobility and rest. Delacroix sought to express rest by a mixture of green and red (of. Signac, sup. cit.).]

The unbounded warmth of red has not the irresponsible appeal of yellow, but rings inwardly with a determined and powerful intensity It glows in itself, maturely, and does not distribute its vigour aimlessly (see Fig. 2).

The varied powers of red are very striking. By a skillful use of it in its different shades, its fundamental tone may be made warm or cold.

[FOOTNOTE: Of course every colour can be to some extent varied between warm and cold, but no colour has so extensive a scale of varieties as red.]

Light warm red has a certain similarity to medium yellow, alike in texture and appeal, and gives a feeling of strength, vigour, determination, triumph. In music, it is a sound of trumpets, strong, harsh, and ringing.

Vermilion is a red with a feeling of sharpness, like glowing steel which can be cooled by water. Vermilion is quenched by blue, for it can support no mixture with a cold colour. More accurately speaking, such a mixture produces what is called a dirty colour, scorned by painters of today. But "dirt" as a material object has its own inner appeal, and therefore to avoid it in painting, is as unjust and narrow as was the cry of yesterday for pure colour. At the call of the inner need that which is outwardly foul may be inwardly pure, and vice versa.

The two shades of red just discussed are similar to yellow, except that they reach out less to the spectator. The glow of red is within itself. For this reason it is a colour more beloved than yellow, being frequently used in primitive and traditional decoration, and also in peasant costumes, because in the open air the harmony of red and green is very beautiful. Taken by itself this red is material, and, like yellow, has no very deep appeal. Only when combined with something nobler does it acquire this deep appeal. It is dangerous to seek to deepen red by an admixture of black, for black quenches the glow, or at least reduces it considerably.

But there remains brown, unemotional, disinclined for movement. An intermixture of red is outwardly barely audible, but there rings out a powerful inner harmony. Skillful blending can produce an inner appeal of extraordinary, indescribable beauty. The vermilion now rings like a great trumpet, or thunders like a drum.

Cool red (madder) like any other fundamentally cold colour, can be deepened—especially by an intermixture of azure. The character of the colour changes; the inward glow increases, the active element gradually disappears. But this active element is never so wholly absent as in deep green. There always remains a hint of renewed vigour, somewhere out of sight, waiting for a certain moment to burst forth afresh. In this lies the great difference between a deepened red and a deepened blue, because in red there is always a trace of the material. A parallel in music are the sad, middle tones of a cello. A cold, light red contains a very distinct bodily or material element, but it is always pure, like the fresh beauty of the face of a young girl. The singing notes of a violin express this exactly in music.

Warm red, intensified by a suitable yellow, is orange. This blend brings red almost to the point of spreading out towards the spectator. But the element of red is always sufficiently strong to keep the colour from flippancy. Orange is like a man, convinced of his own

48

powers. Its note is that of the angelus, or of an old violin.

Just as orange is red brought nearer to humanity by yellow, so violet is red withdrawn from humanity by blue. But the red in violet must be cold, for the spiritual need does not allow of a mixture of warm red with cold blue.

Violet is therefore both in the physical and spiritual sense a cooled red. It is consequently rather sad and ailing. It is worn by old women, and in China as a sign of mourning. In music it is an English horn, or the deep notes of wood instruments (e.g. a bassoon).

[FOOTNOTE: Among artists one often hears the question, "How are you?" answered gloomily by the words "Feeling very violet."]

The two last mentioned colours (orange and violet) are the fourth and last pair of antitheses of the primitive colours. They stand to each other in the same relation as the third antitheses—green and red—i.e., as complementary colours (see Fig. 2).

FIGURE II

```
Second Pair of antitheses      (physical appeal of complementary
        C and D                              colours)

C.       Red            Green       = Third antithesis
        Movement                of the spiritually extinguished
                                        First antithesis

Motion within itself    [CIRCLE]   = Potentiality of motion
                                   = Motionlessness

                        Red

Ex-and concentric movements are absent
                    In optical blend    = Gray
In mechanical blend of white and black  = Gray

D.       Orange             Violet          = Fourth antithesis

Arise out of the first antithesis from:
```

```
1. Active element of the yellow in red    = Orange
2. Passive element of the blue in red     = Violet

[--Orange--Yellow[-[-[-Red-]-]-]Blue--Violet--]

      In excentric      Motion within      In Concentric
        direction          itself            direction
```

As in a great circle, a serpent biting its own tail (the symbol of eternity, of something without end) the six colours appear that make up the three main antitheses. And to right and left stand the two great possibilities of silence—death and birth (see Fig. 3).

FIGURE III.

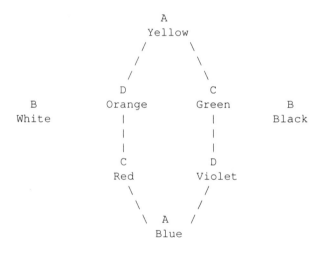

```
                        A
                      Yellow
                     /      \
                    /        \
                   /          \
                 D              C
    B          Orange         Green         B
  White          |              |         Black
                 |              |
                 |              |
                 C              D
                Red           Violet
                  \            /
                   \          /
                    \  A    /
                     Blue
```

The antitheses as a circle between two poles, i.e., the life of colours between birth and death.

(The capital letters designate the pairs of antitheses.)

It is clear that all I have said of these simple colours is very provisional and general, and so also are those feelings (joy, grief, etc.) which have been quoted as parallels of the colours. For these feelings are only the material expressions of the soul. Shades of colour,

like those of sound, are of a much finer texture and awake in the soul emotions too fine to be expressed in words. Certainly each tone will find some probable expression in words, but it will always be incomplete, and that part which the word fails to express will not be unimportant but rather the very kernel of its existence. For this reason words are, and will always remain, only hints, mere suggestions of colours. In this impossibility of expressing colour in words with the consequent need for some other mode of expression lies the opportunity of the art of the future. In this art among innumerable rich and varied combinations there is one which is founded on firm fact, and that is as follows. The actual expression of colour can be achieved simultaneously by several forms of art, each art playing its separate part, and producing a whole which exceeds in richness and force any expression attainable by one art alone. The immense possibilities of depth and strength to be gained by combination or by discord between the various arts can be easily realized.

It is often said that admission of the possibility of one art helping another amounts to a denial of the necessary differences between the arts. This is, however, not the case. As has been said, an absolutely similar inner appeal cannot be achieved by two different arts. Even if it were possible the second version would differ at least outwardly. But suppose this were not the case, that is to say, suppose a repetition of the same appeal exactly alike both outwardly and inwardly could be achieved by different arts, such repetition would not be merely superfluous. To begin with, different people find sympathy in different forms of art (alike on the active and passive side among the creators or the receivers of the appeal); but further and more important, repetition of the same appeal thickens the spiritual atmosphere which is necessary for the maturing of the finest feelings, in the same way as the hot air of a greenhouse is necessary for the ripening of certain fruit. An example of this is the case of the individual who receives a powerful impression from constantly repeated actions, thoughts or feelings, although if they came singly they might have passed by unnoticed. [FOOTNOTE: This idea forms, of course, the fundamental reason for advertisement.] We must not, however, apply this rule only to the simple examples of the spiritual atmosphere. For this atmosphere is like air, which can be either pure or filled with various alien elements. Not only visible actions, thoughts and feelings, with outward expression, make up this atmosphere, but secret happenings of which no one knows, unspoken thoughts, hidden feelings are also elements in it. Suicide, murder, violence, low and unworthy thoughts, hate, hostility, egotism, envy, narrow "patriotism," partisanship, are elements in the spiritual atmosphere.

[FOOTNOTE: Epidemics of suicide or of violent warlike feeling, etc., are products of this impure atmosphere.]

And conversely, self–sacrifice, mutual help, lofty thoughts, love, un–selfishness, joy in the success of others, humanity, justness, are the elements which slay those already enumerated as the sun slays the microbes, and restore the atmosphere to purity.

[FOOTNOTE: These elements likewise have their historical periods.]

The second and more complicated form of repetition is that in which several different elements make mutual use of different forms. In our case these elements are the different arts summed up in the art of the future. And this form of repetition is even more powerful, for the different natures of men respond to the different elements in the combination. For one the musical form is the most moving and impressive; for another the pictorial, for the third the literary, and so on. There reside, therefore, in arts which are outwardly different, hidden forces equally different, so that they may all work in one man towards a single result, even though each art may be working in isolation.

This sharply defined working of individual colours is the basis on which various values can be built up in harmony. Pictures will come to be painted—veritable artistic arrangements, planned in shades of one colour chosen according to artistic feeling. The carrying out of one colour, the binding together and admixture of two related colours, are the foundations of most coloured harmonies. From what has been said above about colour working, from the fact that we live in a time of questioning, experiment and contradiction, we can draw the easy conclusion that for a harmonization on the basis of individual colours our age is especially unsuitable. Perhaps with envy and with a mournful sympathy we listen to the music of Mozart. It acts as a welcome pause in the turmoil of our inner life, as a consolation and as a hope, but we hear it as the echo of something from another age long past and fundamentally strange to us. The strife of colours, the sense of balance we have lost, tottering principles, unexpected assaults, great questions, apparently useless striving, storm and tempest, broken chains, antitheses and contradictions, these make up our harmony. The composition arising from this harmony is a mingling of colour and form each with its separate existence, but each blended into a common life which is called a picture by the force of the inner need. Only these individual parts are vital. Everything else (such as surrounding conditions) is subsidiary. The combination of two colours is a logical outcome of modern conditions. The

combination of colours hitherto considered discordant, is merely a further development. For example, the use, side by side, of red and blue, colours in themselves of no physical relationship, but from their very spiritual contrast of the strongest effect, is one of the most frequent occurrences in modern choice of harmony. [Footnote: Cf. Gauguin, Noa Noa, where the artist states his disinclination when he first arrived in Tahiti to juxtapose red and blue.] Harmony today rests chiefly on the principle of contrast which has for all time been one of the most important principles of art. But our contrast is an inner contrast which stands alone and rejects the help (for that help would mean destruction) of any other principles of harmony. It is interesting to note that this very placing together of red and blue was so beloved by the primitive both in Germany and Italy that it has till today survived, principally in folk pictures of religious subjects. One often sees in such pictures the Virgin in a red gown and a blue cloak. It seems that the artists wished to express the grace of heaven in terms of humanity, and humanity in terms of heaven. Legitimate and illegitimate combinations of colours, contrasts of various colours, the over–painting of one colour with another, the definition of coloured surfaces by boundaries of various forms, the overstepping of these boundaries, the mingling and the sharp separation of surfaces, all these open great vistas of artistic possibility.

One of the first steps in the turning away from material objects into the realm of the abstract was, to use the technical artistic term, the rejection of the third dimension, that is to say, the attempt to keep a picture on a single plane. Modelling was abandoned. In this way the material object was made more abstract and an important step forward was achieved—this step forward has, however, had the effect of limiting the possibilities of painting to one definite piece of canvas, and this limitation has not only introduced a very material element into painting, but has seriously lessened its possibilities.

Any attempt to free painting from this material limitation together with the striving after a new form of composition must concern itself first of all with the destruction of this theory of one single surface—attempts must be made to bring the picture on to some ideal plane which shall be expressed in terms of the material plane of the canvas. [Footnote: Compare the article by Le Fauconnier in the catalogue of the second exhibition of the Neue Kunstlervereinigung, Munich, 1910–11.] There has arisen out of the composition in flat triangles a composition with plastic three–dimensional triangles, that is to say with pyramids; and that is Cubism. But there has arisen here also the tendency to inertia, to a concentration on this form for its own sake, and consequently once more to an impoverishment of possibility. But that is the unavoidable result of the external

application of an inner principle.

A further point of great importance must not be forgotten. There are other means of using the material plane as a space of three dimensions in order to create an ideal plane. The thinness or thickness of a line, the placing of the form on the surface, the overlaying of one form on another may be quoted as examples of artistic means that may be employed. Similar possibilities are offered by colour which, when rightly used, can advance or retreat, and can make of the picture a living thing, and so achieve an artistic expansion of space. The combination of both means of extension in harmony or concord is one of the richest and most powerful elements in purely artistic composition.

VII. THEORY

From the nature of modern harmony, it results that never has there been a time when it was more difficult than it is today to formulate a complete theory, [Footnote: Attempts have been made. Once more emphasis must be laid on the parallel with music. For example, cf. "Tendances Nouvelles," No. 35, Henri Ravel: "The laws of harmony are the same for painting and music."] or to lay down a firm artistic basis. All attempts to do so would have one result, namely, that already cited in the case of Leonardo and his system of little spoons. It would, however, be precipitate to say that there are no basic principles nor firm rules in painting, or that a search for them leads inevitably to academism. Even music has a grammar, which, although modified from time to time, is of continual help and value as a kind of dictionary.

Painting is, however, in a different position. The revolt from dependence on nature is only just beginning. Any realization of the inner working of colour and form is so far unconscious. The subjection of composition to some geometrical form is no new idea (of. the art of the Persians). Construction on a purely abstract basis is a slow business, and at first seemingly blind and aimless. The artist must train not only his eye but also his soul, so that he can test colours for themselves and not only by external impressions.

If we begin at once to break the bonds which bind us to nature, and devote ourselves purely to combination of pure colour and abstract form, we shall produce works which are mere decoration, which are suited to neckties or carpets. Beauty of Form and Colour is no sufficient aim by itself, despite the assertions of pure aesthetes or even of

naturalists, who are obsessed with the idea of "beauty." It is because of the elementary stage reached by our painting that we are so little able to grasp the inner harmony of true colour and form composition. The nerve vibrations are there, certainly, but they get no further than the nerves, because the corresponding vibrations of the spirit which they call forth are too weak. When we remember, however, that spiritual experience is quickening, that positive science, the firmest basis of human thought, is tottering, that dissolution of matter is imminent, we have reason to hope that the hour of pure composition is not far away.

It must not be thought that pure decoration is lifeless. It has its inner being, but one which is either incomprehensible to us, as in the case of old decorative art, or which seems mere illogical confusion, as a world in which full–grown men and embryos play equal roles, in which beings deprived of limbs are on a level with noses and toes which live isolated and of their own vitality. The confusion is like that of a kaleidoscope, which though possessing a life of its own, belongs to another sphere. Nevertheless, decoration has its effect on us; oriental decoration quite differently to Swedish, savage, or ancient Greek. It is not for nothing that there is a general custom of describing samples of decoration as gay, serious, sad, etc., as music is described as Allegro, Serioso, etc., according to the nature of the piece.

Probably conventional decoration had its beginnings in nature. But when we would assert that external nature is the sole source of all art, we must remember that, in patterning, natural objects are used as symbols, almost as though they were mere hieroglyphics. For this reason we cannot gauge their inner harmony. For instance, we can bear a design of Chinese dragons in our dining or bed rooms, and are no more disturbed by it than by a design of daisies.

It is possible that towards the close of our already dying epoch a new decorative art will develop, but it is not likely to be founded on geometrical form. At the present time any attempt to define this new art would be as useless as pulling a small bud open so as to make a fully blown flower. Nowadays we are still bound to external nature and must find our means of expression in her. But how are we to do it? In other words, how far may we go in altering the forms and colours of this nature?

We may go as far as the artist is able to carry his emotion, and once more we see how immense is the need for true emotion. A few examples will make the meaning of this

clearer.

A warm red tone will materially alter in inner value when it is no longer considered as an isolated colour, as something abstract, but is applied as an element of some other object, and combined with natural form. The variety of natural forms will create a variety of spiritual values, all of which will harmonize with that of the original isolated red. Suppose we combine red with sky, flowers, a garment, a face, a horse, a tree.

A red sky suggests to us sunset, or fire, and has a consequent effect upon us—either of splendour or menace. Much depends now on the way in which other objects are treated in connection with this red sky. If the treatment is faithful to nature, but all the same harmonious, the "naturalistic" appeal of the sky is strengthened. If, however, the other objects are treated in a way which is more abstract, they tend to lessen, if not to destroy, the naturalistic appeal of the sky. Much the same applies to the use of red in a human face. In this case red can be employed to emphasize the passionate or other characteristics of the model, with a force that only an extremely abstract treatment of the rest of the picture can subdue.

A red garment is quite a different matter; for it can in reality be of any colour. Red will, however, be found best to supply the needs of pure artistry, for here alone can it be used without any association with material aims. The artist has to consider not only the value of the red cloak by itself, but also its value in connection with the figure wearing it, and further the relation of the figure to the whole picture. Suppose the picture to be a sad one, and the red−cloaked figure to be the central point on which the sadness is concentrated—either from its central position, or features, attitude, colour, or what not. The red will provide an acute discord of feeling, which will emphasize the gloom of the picture. The use of a colour, in itself sad, would weaken the effect of the dramatic whole. [Footnote: Once more it is wise to emphasize the necessary inadequacy of these examples. Rules cannot be laid down, the variations are so endless. A single line can alter the whole composition of a picture.] This is the principle of antithesis already defined. Red by itself cannot have a sad effect on the spectator, and its inclusion in a sad picture will, if properly handled, provide the dramatic element. [Footnote: The use of terms like "sad" and "joyful" are only clumsy equivalents for the delicate spiritual vibrations of the new harmony. They must be read as necessarily inadequate.]

Yet again is the case of a red tree different. The fundamental value of red remains, as in every case. But the association of "autumn" creeps in.

The colour combines easily with this association, and there is no dramatic clash as in the case of the red cloak.

Finally, the red horse provides a further variation. The very words put us in another atmosphere. The impossibility of a red horse demands an unreal world. It is possible that this combination of colour and form will appeal as a freak—a purely superficial and non−artistic appeal—or as a hint of a fairy story [Footnote: An incomplete fairy story works on the mind as does a cinematograph film.]—once more a non−artistic appeal. To set this red horse in a careful naturalistic landscape would create such a discord as to produce no appeal and no coherence. The need for coherence is the essential of harmony—whether founded on conventional discord or concord. The new harmony demands that the inner value of a picture should remain unified whatever the variations or contrasts of outward form or colour. The elements of the new art are to be found, therefore, in the inner and not the outer qualities of nature.

The spectator is too ready to look for a meaning in a picture— i.e., some outward connection between its various parts. Our materialistic age has produced a type of spectator or "connoisseur," who is not content to put himself opposite a picture and let it say its own message. Instead of allowing the inner value of the picture to work, he worries himself in looking for "closeness to nature," or "temperament," or "handling," or "tonality," or "perspective," or what not. His eye does not probe the outer expression to arrive at the inner meaning. In a conversation with an interesting person, we endeavour to get at his fundamental ideas and feelings. We do not bother about the words he uses, nor the spelling of those words, nor the breath necessary for speaking them, nor the movements of his tongue and lips, nor the psychological working on our brain, nor the physical sound in our ear, nor the physiological effect on our nerves. We realize that these things, though interesting and important, are not the main things of the moment, but that the meaning and idea is what concerns us. We should have the same feeling when confronted with a work of art. When this becomes general the artist will be able to dispense with natural form and colour and speak in purely artistic language.

To return to the combination of colour and form, there is another possibility which should be noted. Non−naturalistic objects in a picture may have a "literary" appeal, and the

whole picture may have the working of a fable. The spectator is put in an atmosphere which does not disturb him because he accepts it as fabulous, and in which he tries to trace the story and undergoes more or less the various appeals of colour. But the pure inner working of colour is impossible; the outward idea has the mastery still. For the spectator has only exchanged a blind reality for a blind dreamland, where the truth of inner feeling cannot be felt.

We must find, therefore, a form of expression which excludes the fable and yet does not restrict the free working of colour in any way. The forms, movement, and colours which we borrow from nature must produce no outward effect nor be associated with external objects. The more obvious is the separation from nature, the more likely is the inner meaning to be pure and unhampered.

The tendency of a work of art may be very simple, but provided it is not dictated by any external motive and provided it is not working to any material end, the harmony will be pure. The most ordinary action—for example, preparation for lifting a heavy weight—becomes mysterious and dramatic, when its actual purpose is not revealed. We stand and gaze fascinated, till of a sudden the explanation bursts suddenly upon us. It is the conviction that nothing mysterious can ever happen in our everyday life that has destroyed the joy of abstract thought. Practical considerations have ousted all else. It is with this fact in view that the new dancing is being evolved—as, that is to say, the only means of giving in terms of time and space the real inner meaning of motion. The origin of dancing is probably purely sexual. In folk–dances we still see this element plainly. The later development of dancing as a religious ceremony joins itself to the preceding element and the two together take artistic form and emerge as the ballet.

The ballet at the present time is in a state of chaos owing to this double origin. Its external motives—the expression of love and fear, etc.—are too material and naive for the abstract ideas of the future. In the search for more subtle expression, our modern reformers have looked to the past for help. Isadora Duncan has forged a link between the Greek dancing and that of the future. In this she is working on parallel lines to the painters who are looking for inspiration from the primitives.

[Footnote: Kandinsky's example of Isadora Duncan is not perhaps perfectly chosen. This famous dancer founds her art mainly upon a study of Greek vases and not necessarily of the primitive period. Her aims are distinctly towards what Kandinsky calls "conventional

beauty," and what is perhaps more important, her movements are not dictated solely by the "inner harmony," but largely by conscious outward imitation of Greek attitudes. Either Nijinsky's later ballets: Le Sacre du Printemps, L'Apres–midi d'un Faune, Jeux, or the idea actuating the Jacques Dalcroze system of Eurhythmics seem to fall more into line with Kandinsky's artistic forecast. In the first case "conventional beauty" has been abandoned, to the dismay of numbers of writers and spectators, and a definite return has been made to primitive angles and abruptness. In the second case motion and dance are brought out of the souls of the pupils, truly spontaneous, at. the call of the "inner harmony." Indeed a comparison between Isadora Duncan and M. Dalcroze is a comparison between the "naturalist" and "symbolist" ideals in art which were outlined in the introduction to this book.—M.T.H.S.]

In dance as in painting this is only a stage of transition. In dancing as in painting we are on the threshold of the art of the future. The same rules must be applied in both cases. Conventional beauty must go by the board and the literary element of "story–telling" or "anecdote" must be abandoned as useless. Both arts must learn from music that every harmony and every discord which springs from the inner spirit is beautiful, but that it is essential that they should spring from the inner spirit and from that alone.

The achievement of the dance–art of the future will make possible the first ebullition of the art of spiritual harmony—the true stage–composition.

The composition for the new theatre will consist of these three elements:

```
(1) Musical movement
(2) Pictorial movement
(3) Physical movement
```

and these three, properly combined, make up the spiritual movement, which is the working of the inner harmony. They will be interwoven in harmony and discord as are the two chief elements of painting, form and colour.

Scriabin's attempt to intensify musical tone by corresponding use of colour is necessarily tentative. In the perfected stage– composition the two elements are increased by the third, and endless possibilities of combination and individual use are opened up. Further, the external can be combined with the internal harmony, as Schonberg has attempted in his

quartettes. It is impossible here to go further into the developments of this idea. The reader must apply the principles of painting already stated to the problem of stage–composition, and outline for himself the possibilities of the theatre of the future, founded on the immovable principle of the inner need.

From what has been said of the combination of colour and form, the way to the new art can be traced. This way lies today between two dangers. On the one hand is the totally arbitrary application of colour to geometrical form—pure patterning. On the other hand is the more naturalistic use of colour in bodily form—pure phantasy. Either of these alternatives may in their turn be exaggerated. Everything is at the artist's disposal, and the freedom of today has at once its dangers and its possibilities. We may be present at the conception of a new great epoch, or we may see the opportunity squandered in aimless extravagance.

[Footnote: On this question see my article "Uber die Formfrage"— in "Der Blaue Reiter" (Piper–Verlag, 1912). Taking the work of Henri Rousseau as a starting point, I go on to prove that the new naturalism will not only be equivalent to but even identical with abstraction.]

That art is above nature is no new discovery. [Footnote: Cf. "Goethe", by Karl Heinemann, 1899, p. 684; also Oscar Wilde, "De Profundis"; also Delacroix, "My Diary".] New principles do not fall from heaven, but are logically if indirectly connected with past and future. What is important to us is the momentary position of the principle and how best it can be used. It must not be employed forcibly. But if the artist tunes his soul to this note, the sound will ring in his work of itself. The "emancipation" of today must advance on the lines of the inner need. It is hampered at present by external form, and as that is thrown aside, there arises as the aim of composition– construction. The search for constructive form has produced Cubism, in which natural form is often forcibly subjected to geometrical construction, a process which tends to hamper the abstract by the concrete and spoil the concrete by the abstract.

The harmony of the new art demands a more subtle construction than this, something that appeals less to the eye and more to the soul. This "concealed construction" may arise from an apparently fortuitous selection of forms on the canvas. Their external lack of cohesion is their internal harmony. This haphazard arrangement of forms may be the future of artistic harmony. Their fundamental relationship will finally be able to be

expressed in mathematical form, but in terms irregular rather than regular.

VIII. ART AND ARTISTS

The work of art is born of the artist in a mysterious and secret way. From him it gains life and being. Nor is its existence casual and inconsequent, but it has a definite and purposeful strength, alike in its material and spiritual life. It exists and has power to create spiritual atmosphere; and from this inner standpoint one judges whether it is a good work of art or a bad one. If its "form" is bad it means that the form is too feeble in meaning to call forth corresponding vibrations of the soul.

[Footnote: So–called indecent pictures are either incapable of causing vibrations of the soul (in which case they are not art) or they are so capable. In the latter case they are not to be spurned absolutely, even though at the same time they gratify what nowadays we are pleased to call the "lower bodily tastes."] Therefore a picture is not necessarily "well painted" if it possesses the "values" of which the French so constantly speak. It is only well painted if its spiritual value is complete and satisfying. "Good drawing" is drawing that cannot be altered without destruction of this inner value, quite irrespective of its correctness as anatomy, botany, or any other science. There is no question of a violation of natural form, but only of the need of the artist for such form. Similarly colours are used not because they are true to nature, but because they are necessary to the particular picture. In fact, the artist is not only justified in using, but it is his duty to use only those forms which fulfil his own need. Absolute freedom, whether from anatomy or anything of the kind, must be given the artist in his choice of material. Such spiritual freedom is as necessary in art as it is in life. [Footnote: This freedom is man's weapon against the Philistines. It is based on the inner need.]

Note, however, that blind following of scientific precept is less blameworthy than its blind and purposeless rejection. The former produces at least an imitation of material objects which may be of some use.

[Footnote: Plainly, an imitation of nature, if made by the hand of an artist, is not a pure reproduction. The voice of the soul will in some degree at least make itself heard. As contrasts one may quote a landscape of Canaletto and those sadly famous heads by Denner.—(Alte Pinakothek, Munich.)]

The latter is an artistic betrayal and brings confusion in its train. The former leaves the spiritual atmosphere empty; the latter poisons it.

Painting is an art, and art is not vague production, transitory and isolated, but a power which must be directed to the improvement and refinement of the human soul—to, in fact, the raising of the spiritual triangle.

If art refrains from doing this work, a chasm remains unbridged, for no other power can take the place of art in this activity. And at times when the human soul is gaining greater strength, art will also grow in power, for the two are inextricably connected and complementary one to the other. Conversely, at those times when the soul tends to be choked by material disbelief, art becomes purposeless and talk is heard that art exists for art's sake alone.

[Footnote: This cry "art for art's sake," is really the best ideal such an age can attain to. It is an unconscious protest against materialism, against the demand that everything should have a use and practical value. It is further proof of the indestructibility of art and of the human soul, which can never be killed but only temporarily smothered.]

Then is the bond between art and the soul, as it were, drugged into unconsciousness. The artist and the spectator drift apart, till finally the latter turns his back on the former or regards him as a juggler whose skill and dexterity are worthy of applause. It is very important for the artist to gauge his position aright, to realize that he has a duty to his art and to himself, that he is not king of the castle but rather a servant of a nobler purpose. He must search deeply into his own soul, develop and tend it, so that his art has something to clothe, and does not remain a glove without a hand.

THE ARTIST MUST HAVE SOMETHING TO SAY, FOR MASTERY OVER FORM IS NOT HIS GOAL BUT RATHER THE ADAPTING OF FORM TO ITS INNER MEANING.

[Footnote: Naturally this does not mean that the artist is to instill forcibly into his work some deliberate meaning. As has been said the generation of a work of art is a mystery. So long as artistry exists there is no need of theory or logic to direct the painter's action. The inner voice of the soul tells him what form he needs, whether inside or outside nature. Every artist knows, who works with feeling, how suddenly the right form flashes

upon him. Bocklin said that a true work of art must be like an inspiration; that actual painting, composition, etc., are not the steps by which the artist reaches self–expression.]

The artist is not born to a life of pleasure. He must not live idle; he has a hard work to perform, and one which often proves a cross to be borne. He must realize that his every deed, feeling, and thought are raw but sure material from which his work is to arise, that he is free in art but not in life.

The artist has a triple responsibility to the non–artists: (1) He must repay the talent which he has; (2) his deeds, feelings, and thoughts, as those of every man, create a spiritual atmosphere which is either pure or poisonous. (3) These deeds and thoughts are materials for his creations, which themselves exercise influence on the spiritual atmosphere. The artist is not only a king, as Peladan says, because he has great power, but also because he has great duties.

If the artist be priest of beauty, nevertheless this beauty is to be sought only according to the principle of the inner need, and can be measured only according to the size and intensity of that need.

THAT IS BEAUTIFUL WHICH IS PRODUCED BY THE INNER NEED, WHICH SPRINGS FROM THE SOUL.

Maeterlinck, one of the first warriors, one of the first modern artists of the soul, says: "There is nothing on earth so curious for beauty or so absorbent of it, as a soul. For that reason few mortal souls withstand the leadership of a soul which gives to them beauty." [Footnote: De la beaute interieure.]

And this property of the soul is the oil, which facilitates the slow, scarcely visible but irresistible movement of the triangle, onwards and upwards.

IX. CONCLUSION

The first five illustrations in this book show the course of constructive effort in painting. This effort falls into two divisions:

(1) Simple composition, which is regulated according to an obvious and simple form. This kind of composition I call the MELODIC.

(2) Complex composition, consisting of various forms, subjected more or less completely to a principal form. Probably the principal form may be hard to grasp outwardly, and for that reason possessed of a strong inner value. This kind of composition I call the SYMPHONIC.

Between the two lie various transitional forms, in which the melodic principle predominates. The history of the development is closely parallel to that of music.

If, in considering an example of melodic composition, one forgets the material aspect and probes down into the artistic reason of the whole, one finds primitive geometrical forms or an arrangement of simple lines which help toward a common motion. This common motion is echoed by various sections and may be varied by a single line or form. Such isolated variations serve different purposes. For instance, they may act as a sudden check, or to use a musical term, a "fermata." [Footnote: E.g., the Ravenna mosaic which, in the main, forms a triangle. The upright figures lean proportionately to the triangle. The outstretched arm and door–curtain are the "fermate."] Each form which goes to make up the composition has a simple inner value, which has in its turn a melody. For this reason I call the composition melodic. By the agency of Cezanne and later of Hodler [Footnote: English readers may roughly parallel Hodler with Augustus John for purposes of the argument.—M.T.H.S.] this kind of composition won new life, and earned the name of "rhythmic." The limitations of the term "rhythmic" are obvious. In music and nature each manifestation has a rhythm of its own, so also in painting. In nature this rhythm is often not clear to us, because its purpose is not clear to us. We then speak of it as unrhythmic. So the terms rhythmic and unrhythmic are purely conventional, as also are harmony and discord, which have no actual existence. [Footnote: As an example of plain melodic construction with a plain rhythm, Cezanne's "Bathing Women" is given in this book.]

Complex rhythmic composition, with a strong flavour of the symphonic, is seen in numerous pictures and woodcuts of the past. One might mention the work of old German masters, of the Persians, of the Japanese, the Russian icons, broadsides, etc. [Footnote: This applies to many of Hodler's pictures.]

Concerning the Spiritual in Art

In nearly all these works the symphonic composition is not very closely allied to the melodic. This means that fundamentally there is a composition founded on rest and balance. The mind thinks at once of choral compositions, of Mozart and Beethoven. All these works have the solemn and regular architecture of a Gothic cathedral; they belong to the transition period.

As examples of the new symphonic composition, in which the melodic element plays a subordinate part, and that only rarely, I have added reproductions of four of my own pictures.

They represent three different sources of inspiration:

(1) A direct impression of outward nature, expressed in purely artistic form. This I call an "Impression."

(2) A largely unconscious, spontaneous expression of inner character, the non-material nature. This I call an "Improvisation."

(3) An expression of a slowly formed inner feeling, which comes to utterance only after long maturing. This I call a "Composition." In this, reason, consciousness, purpose, play an overwhelming part. But of the calculation nothing appears, only the feeling. Which kind of construction, whether conscious or unconscious, really underlies my work, the patient reader will readily understand.

Finally, I would remark that, in my opinion, we are fast approaching the time of reasoned and conscious composition, when the painter will be proud to declare his work constructive. This will be in contrast to the claim of the Impressionists that they could explain nothing, that their art came upon them by inspiration. We have before us the age of conscious creation, and this new spirit in painting is going hand in hand with the spirit of thought towards an epoch of great spiritual leaders.

Printed in the United States
222246BV00002B/1/A

9 781419 113772